1987

BILL BRANDT Behind the Camera

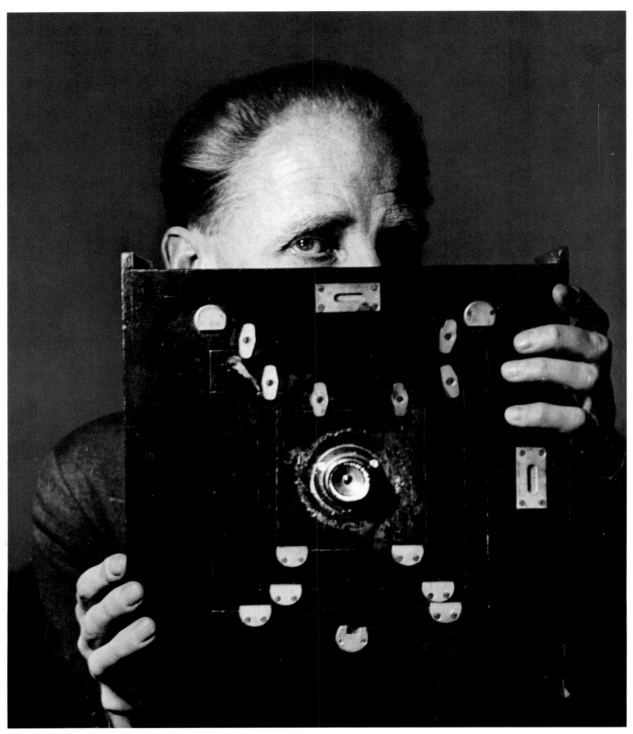

Bill Brandt, 1945, by Laelia Goehr

It is part of the photographer's job to see more intensely than most people do. He must have and keep in him something of the receptiveness of the child who looks at the world for the first time or of the traveller who enters a strange country. BILL BRANDT, *Camera in London*, 1948

BILL BRANDT
Behind the Camera
PHOTOGRAPHS 1928-1983

Introductions by MARK HAWORTH-BOOTH

Essay by DAVID MELLOR

AN APERTURE MONOGRAPH

ACKNOWLEDGEMENTS
We are indebted to the following for their contribution to this publication: Noya Brandt, R.A. Brandt, Sir Brian Batsford, Peter Brandt, Brian Coe (Kodak Museum, England), Dr. Desmond Flower, Michel Frizot, Florence Gremeaux, Martin Harrison (Olympus Gallery, London), Sir Tom Hopkinson, Peter Kernot (Executor of the Estate of Bill Brandt), David Lee (BBC Hulton Picture Library), Barbara Lloyd (Marlborough Fine Art, London), Colin Osman and his colleagues (*Creative Camera,* London), Terence Pepper (National Portrait Gallery, London), Mrs. Eva Rakos, Michael Regan (Arts Council of Great Britain), Mrs. Francis Rice, Arthur Tapp, Christopher Titterington (Victoria and Albert Museum, London), Marco de Valdivia, John Ward (Science Museum, London).

Bill Brandt: Behind the Camera, Photographs 1928–1983 is an exhibition presented by the Philadelphia Museum of Art from June 8 to September 21, 1985, which will travel to major institutions.

Composition by David E. Seham Assoc., Inc., Metuchen, New Jersey; Duotone negatives by Robert Hennessey; Printed and bound by Amilcare Pizzi, S.p.A., Milan, Italy. Library of Congress Catalog Card Number: 84-73422. ISBN: 0-89381-170-X, cloth edition; ISBN: 0-89381-191-2, museum catalog edition.

Aperture, a division of Silver Mountain Foundation, Inc., publishes a periodical, books, and portfolios of fine photography to communicate with serious photographers and creative people everywhere. A complete catalog is available upon request. Address: Aperture, 20 E. 23rd Street, New York City, New York 10010; and Aperture, Millerton, New York 12546

CONTENTS

EUROPEAN BACKGROUND

Caledonian Market, 1929

He wasn't interested in anything that didn't lend itself to mystery. The mystery was in Bill, and he projected it on to whatever he photographed. SIR TOM HOPKINSON

These words were spoken by one of Bill Brandt's oldest friends in a radio tribute in 1984. They are fundamental and true to any accurate portrait of the photographer. Without being aloof or cold, he preserved a barrier of mystery between himself and even his closest friends. He shunned publicity and succeeded in being thought of as a photographer and not a personality. And it is perhaps because of his mystery that, despite his position as one of the great creative masters of the medium, he was not the subject of any standard historical inquiry until very recently.

He invented a role for himself which now seems a surprising act of originality; all the more so when his antecedents and early life are considered. Although London is often cited as the place of Brandt's birth, he was actually born in Hamburg. His father, L.W. Brandt, was a British subject, but his family background was continental European. In 1900, L.W. Brandt, head of an import/export firm, married Lili Merck, daughter of a Hamburg family noted for public service and their interest in the arts. Bill Brandt was born Hermann Wilhelm Brandt on May 3, 1904, the second of four sons. Rolf Brandt was born in 1906. Of the four brothers, Bill and Rolf were thought to have inherited the Merck family traits. As boys they attended drawing lessons given by K.E. Ort, a Czech architect they much admired, at the Kunstgewerbeschule. Their mother took in art periodicals such as *Das Plakat*, an up-to-date magazine of graphic, notably poster, art which featured such innovators as Lucian Bernhard, Julius Klinger and Ludwig Hohlwein, and she owned posters by Lautrec. A small watercolor by Bill Brandt, in 1918, from the collection of Rolf Brandt, depicts the family house at Gross Fontenay 1 and has, in addition to its charm, some interest in relation to Bill Brandt's later work. The house is presented frontally and in the center of the sheet; its youthful painter took the trouble to mix four slightly different tones of grey to represent grey stucco, grey curtains, the grey moldings that ornament the windows, and the grey of the interiors. However, if the little painting shows a sense of the nuances of the grey scale that might be thought promising in a boy of fourteen, and presents the family home under a

Racegoers, Paris, 1931

cheerful aspect, as a schoolboy Bill Brandt was withdrawn. In consequence he was thought backward and in need of special coaching and so was placed in the household of a teacher at the town of Elmshorn in neighboring Schleswig-Holstein. Brandt's school days were intensely unhappy. At sixteen he succumbed to tuberculosis and was sent for treatment to a sanitorium in Davos, Switzerland, where he remained for six years. At Davos reports were heard of a doctor in Vienna who claimed to be able to cure many dangerous sicknesses, including tuberculosis, by psychoanalysis. Bill Brandt travelled to Vienna for treatment in 1927. His brother Rolf had already

befriended a remarkable woman whose activities and social circle were at the center of Viennese cultural life, Dr. Eugenie Schwarzwald. When she heard from Rolf Brandt of his brother's course of treatment for tuberculosis by a psychoanalyst, she took him at once to a leading lung specialist. The young man was pronounced free of infection. Dr. Schwarzwald then stirred herself to find a career for her protegé. Rolf Brandt recalls that she sat down with Bill Brandt and nominated suitable careers, checking them off on her fingers one by one. For no known reason Bill Brandt stopped her at photography. She placed him with a portrait studio in the city, run by a former pupil, to

learn. Here Bill Brandt met the Hungarian girl who was to become his first wife, Eva Boros.

Perhaps even at this stage Bill Brandt was aware that photography was "in the air" and on the verge of great changes. The first volume of an important series of annuals, *Das Deutches Lichtbild*, was published in Berlin in 1928. The plates provided a panoramic view of available modes of photography. Essays by leading photographers offered new perspectives. From London, E.O. Hoppé—doyen of portrait, new industrial and genre photography—wrote that the "intelligent appreciation of photography is undoubtedly increasing" and the way was now prepared for "a younger generation of enthusiasts." He claimed a free, experimental condition for the medium:

> The free conception of photography can only exist on a free and unconstrained basis, taken from the pulse of life, and this can best be judged by one who is solely interested as a spectator and who can contemplate the effect produced by the mind behind the camera with true artistic pleasure.

Hoppé celebrated the "artist behind the camera," who "ordains, selects and eliminates . . . seizes and controls the fugitive and significant vibrations of light, time and mood in nature and in life, and records them permanently." This is a text Brandt may well have read at about the time he adopted photography in Vienna—equally he may have responded to a new sense of excitement about photography that took many forms and strongly attracted others of his generation and class.

In spring 1928 the American poet Ezra Pound visited Vienna and the Schwarzwalds. It was arranged that Bill Brandt should take his portrait. He produced an image which captured Pound's flamboyance, his ebullience and perhaps—to later eyes—his mania. Pound's pleasure in the portrait resulted in the offer of an introduction to the major master of photography in Paris, Man Ray. It is characteristic of Bill Brandt that the Pound portrait lay unexhibited and unpublished until 1982. It is also typical of his reticence that he should later speak of his introduction to Man Ray as simply through "a family friend" (unnamed).

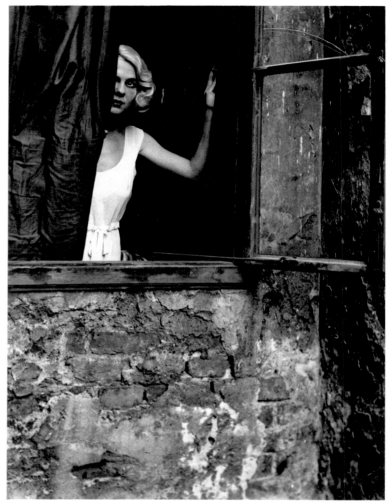

Vienna, 1933

However, perhaps it is most deeply characteristic that in later times Bill Brandt never spoke of being in Vienna at all. Perhaps he gained from the city not only an end of convalescence and a beginning in photography but confirmation of some quality in himself that seems—now—at the heart of his achievement. Perhaps this quality—a dramatic instinct allied to supreme tact—showed itself, at once, in the ease with which he photographed the Ezra Pound that Pound thought himself to be. The same quality became even more evident in the photographs of individuals of all social classes and environments which were to characterize Bill Brandt's major work in the 30's.

Bill Brandt worked in the studio of Man Ray in Paris for about three months in 1929. Man Ray was not, apparently, a particularly helpful master. He explained little about what he was doing and the processes involved but Brandt remembered the time with gratitude. Brandt had been placed at the center of Paris Surrealism. He saw drawers full of Man Ray's prints, new magazines, new books and the major Surrealist films, notably *L'Age d'Or* (1930) and *Un Chien Ándalou* (1928) by Luis Buñuel and Salvador Dali. The disturbance of pictorial logic in the service of social dislocation and the irradiation of fact by fantasy were new experiences eagerly sought and accepted by Bill Brandt. Afterwards they remained part of the second-nature of his sensibility.

Little has been known until recently about how Brandt absorbed these new experiences into his own photography. A group of Brandt's early prints—small and carefully mounted on cards, much in the manner of prints from the same period by André Kertész—has been preserved by his brother Rolf. They were taken with the first camera Bill Brandt used, a Zeiss-Ikon Miroflex which took glass negatives of 3¼ x 2½ inches. Introduced in 1926, the Miroflex was a good quality professional camera with one notable technical feature. Its wire-frame viewfinder could be swung up to make the camera a press-type model for use at eye-level for action subjects. However, when the folded hood on the top of the camera was erected, a reflex mirror dropped into position and the Miroflex became a single-lens reflex. Brandt's first camera offered him the

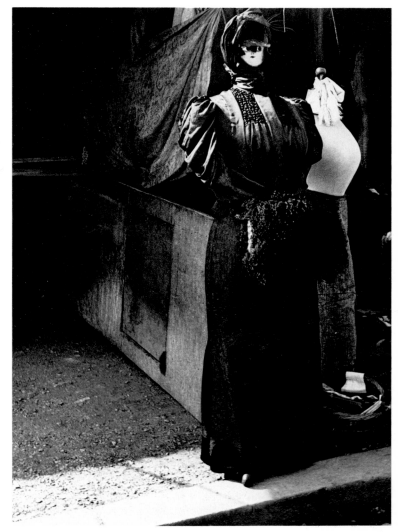

Flea Market, Paris, 1929

9

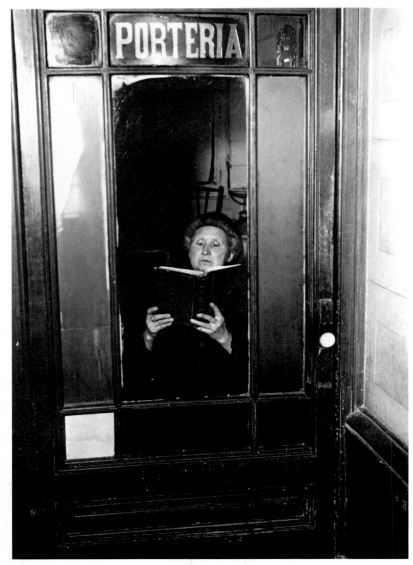

Barcelona, 1932

opportunity of either following movement or, on the other hand, carefully composing still subjects. The camera suggests the different ways in which Brandt's career might have evolved. Many of these early images appear on these pages.

The earliest dated photograph in the collection owned by Rolf Brandt is *Caledonian Market* (1929), taken on a short trip to England. It shows a street trader offering the assorted wares spread around her on a London pavement. This became one of Brandt's earliest published photographs (in *Das Deutsches Lichtbild 1932*) and the earliest photograph in his first book *The English at Home* (1936). *Aux marché aux puces*, taken in Paris in 1929, shows a flea market mannequin figure transformed into a shadowed effigy. This photograph is a chiaroscuro dramatization of one of Atget's original themes. *Paris—St. Ouen* (November 1930) is Brandt's first attempt to capture movement— boys playing in the street. As he later said, his first street photographs disappointed him. He came to realize that he was not close enough. *Paris* (June 1931) is a view from one of the bridges downstream from the Eiffel tower. The combined subject of laborer, scaffolding and the city link this photograph with the pictorial types evolved by Kertész. *Paris-Auteuil* (April 1931) shows two bowler-hatted men at the races, looking askance. Covert views of spectators, who are shown gazing at spectacles unknown, are typical of the intimate street realism much practiced at the time by, for example, Kertész and Cartier-Bresson. Another picture from the same place and date shows a dignified gentleman seated incongruously among race track debris. Race tracks were a favorite haunt for Brandt in the 30's, and he later sharpened his view of the Turf as a site of social contrast. A visit to Hungary some time in the 30's yielded a view taken in the Hungarian wastes of an enormous, mud-bound pig. This brutish apotheosis is reminiscent of the cinema of Buñuel-Dali. Also from Hungary is a photograph of a tottering, drunken postman, a type of the vagabond, or *isolé*, well-established in Brandt's work at this time. *Barcelona* (April 1932) shows an example of Brandt's views of individuals enclosed by, but apparently oblivious to, their social roles. Here a woman reads unconcernedly in a box emblazoned ''Porteria.'' An

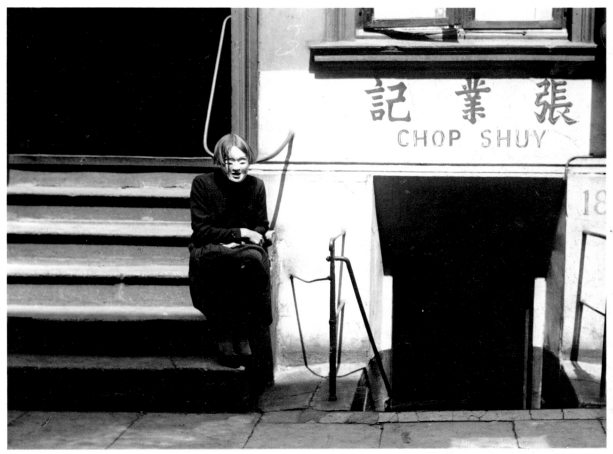

Hamburg, date unknown

undated photograph from the China Town district of St. Pauli in Hamburg shows a young woman seated on the street by a Chop Suey restaurant. She wears a Chinese mask. In fact, the young woman was Rolf Brandt's wife, Esther. The photograph could have been taken at several different dates in the 30's. With other pictures in the group, the St. Pauli photograph suggests Brandt's interest in a kind of photography in which reality and theatrical illusion interact and become inseparable. Finally, there is a portrait of his wife Eva, leaning from a window (October 1933). According to his brother Rolf, Brandt tried to cast Eva—through make-up, lighting, red paint on the negative, and setting—in the role of a prostitute. Like the China Town photograph, this invention is of some importance in viewing later works and sensing Brandt's understanding of the medium.

Paris brought Bill Brandt, preeminently, the revelation of the work of Atget. His photographs of the *Caledonian Market* and *Aux marché aux puces* are *hommages* to the street traders and paraphernalia of Atget. When Atget's photographs first appeared in book form in 1930, the plates were prefaced by a text, set in the expansive type-size of a proclamation, which served as a manifesto for photography in the modern era. Critic Pierre Mac-Orlan paused to place Atget in a saintly niche and beckoned to a new consciousness: the aesthetic spectacle of modern cities in movement and, neon-lit, at night. The subject of his introduction to Atget is really the phenomenon of photography. His essay may have been the first of its type that Brandt ever encountered. Mac-Orlan wrote of photographers as the heirs of François Villon, as the poets of the city. He referred to the tireless wanderings of Atget in the streets of Paris and his insatiable curiosity about the fabric of the city in all its details. He spoke of the arbitrary truth of the still photograph as profound interpreter of movement, just as, by another paradox, light is revealed by shadows. These statements contain much that reaches fruition in Bill Brandt's work.

THE ENGLISH AT HOME

Bill Brandt and Eva came to London together in 1931, travelled to Barcelona where they married in 1932, then established themselves in a flat in Belsize Park, north London. 58 Hillfield Court was a small, first-floor apartment in a new, nondescript brick building. It was perched on the gentle incline that joined Camden Town, peopled by artists and members of the working-class, to Hampstead with its middle-class and intellectual community. The kitchen served as Brandt's darkroom. As a child Brandt had heard much of London, England and English ways. With great enthusiasm, he wrote of what he saw to his brother Rolf, who was by then an actor in Berlin.

In the summer of 1933, Brandt published some photographs as illustrations to the column of a friend in the daily paper, *The News Chronicle*. Yet his photography at this period was, for the most part, self-motivated. Between 1931 and the end of 1935, he produced the photographs which appeared in his first book, *The English at Home*, published in spring 1936. A dummy of the book had been shown to publishers by Rolf Brandt, who came to England with Esther, his wife, in 1934. The book was declined by the leading art publisher Anton Swemmer who dismissed the first photograph—a gull in the fog over the Thames—as a fake, a collage, he said, of two separate prints. He added that the book was not "erotic" enough. The literary and general publishers Chatto and Windus also declined the book, but B.T. Batsford Ltd. were interested at once. Speaking about the book recently, Sir Brian Batsford recalled that, although the firm never published works brought in on speculation, the photographs interested him. He also thought that the book might solve a particular publishing problem. He explained that London publishers were at the time trying to emulate the huge commercial success of a series of cheap photo-books called "Die Blauen Bücher" which were produced in Leipzig. This series covered works of art and architecture and separate towns and cities. "We thought that *The English at Home* was the answer to it," Batsford stated. One "sheet" of printing paper would print 128 pages at the standard size used for a novel. This would be the size of *The English at Home*. In order to print another book simultaneously and waste almost nothing of the sheet, the quantity of plates in *The English at Home* was set at 63. Batsford had published Paul Cohen-Kortheim's *The Spirit of London* in 1935, which contained a preface by Raymond Mortimer and some aerial photographs from Aerofilms Ltd. A pair of these

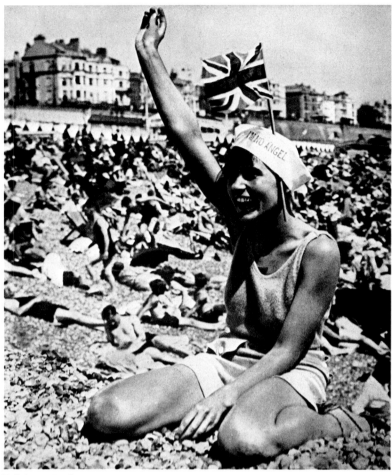

Brighton Belle

Aerofilm views embellish the end-papers of *The English at Home* (a pattern of typical urban housing at the start, countryside at the end) and Mortimer was again enlisted as the preface writer. The plates, printed in a warm-toned photogravure by the Sun Engraving Co, London, are far higher in quality than the standard of "Die Blauen Bücher"; and the plates are laid out to form a series of contrasts. The book's covers contrast, on the front, elite spectators on Royal Hunt Cup Day at Ascot with, on the back, a miner's family in wretched circumstances. Contrasts of this sharpness are not characteristic of the layout inside. Raymond Mortimer addressed four themes in his eight-page introduction. He wrote of the habitual blindness of natives to the actual appearance of their society. A returning traveller might enjoy, for a time at least, the virtues of detachment. "Soon familiarity blinds you again, but for an hour or two you have caught a surprising vision of your country and your countrymen: you have noticed a hundred details which are peculiar to England; you have, in fact, been able to look through foreign eyes." Second, Mortimer wrote of Bill Brandt's advantages. His eyes *were* foreign and they belonged to an artist. For Mortimer this meant not only a capacity to be surprised and excited by English life, but an understanding of picture-making, "notably in the Billingsgate Porter, where there is skillful analogy between the silvery smoothness of the fish and the blank simplicity of the face beneath it, as below some extravagant medieval head-dress." Third, Mortimer—a regular writer for *Vogue*—dealt with the variety of social/cultural codes displayed in clothing and other signs. Finally, he referred to the social contrasts recorded in the book and wrote of the drastic necessity of amelioration. No reviews of the book have been traced but Sir Brian Batsford admitted that his firm had not yet found the winning formula for commercial success. *The English at Home* was unprecedented—and unsuccessful. Bill Brandt wrote to Sir Brian Batsford many years later, on December 4, 1978:

At the time before the war you were the only publisher who was interested in my photographs. It may amuse you to hear that I saw the other day an advertisement in an American magazine in which they offered a second-hand (damaged) edition of *The English at Home* for $500. In 1936 you sold the book for five shillings and as you may remember after some years it had to be remaindered!

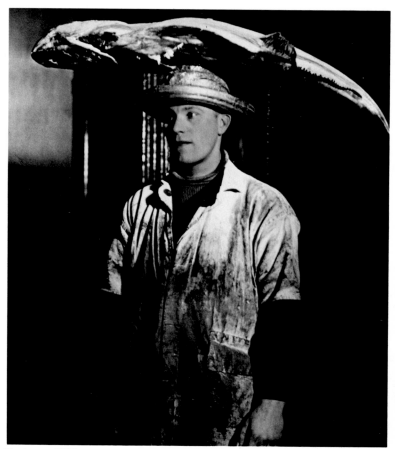

Porter at Billingsgate

The English at Home has become a famous volume because it was unique in its time. Technically, Brandt had the opportunity of exploring night and the interior with the newly developed flash-bulb. The "Vacublitz" was introduced in Germany in the late 20's and manufactured under license in Britain from 1930. Second, Bill Brandt found in Britain a whole cast ready to act in his photographic dramatization of daily life. The Surrey country houses and London drawing rooms of his banker uncles provided a mise-en-scène in which late Edwardian manners held confident sway; they easily accommodated the presence of an enthusiastic, photographic nephew. Eva, Rolf and other friends of the time played roles in Brandt's photographs: as lovers in the park, sun-worshippers on the beach. Esther Brandt appeared as a Brighton belle, complete with an "I'm No Angel" sun hat. The photography is panoramic, however, and access to such a range of subject—down a coal mine in Wales, in a Salvation Army dormitory and inside poor homes in London's East End—required initiative, persistence, tact and, most of all, a rare completeness of social vision.

What seems increasingly remarkable is Brandt's recognition of the subject to be explored. The relative unpopularity and subsequent remaindering of the book almost attests to his originality in this respect. A principal novelist of the period shared Brandt's unusual—even uncanny—point of view. Rosamond Lehmann's novels from the 30's have been reissued with great success in recent years. Her novel *The Weather in the Streets*—which almost evokes a book of Brandt's photographs by its title alone—was published contemporaneously with *The English at Home* in 1936. The novel displays a sensibility that is remarkably close to Brandt's. There is the same sense of intimacy and detachment, the same sense of action—a game of backgammon, it might be—suddenly freezing into a document of history. The entrance of a new personality into an elegant, country house drawing room, for example, suddenly:

> somehow co-ordinated ordinary objects, actions, characters, and transmuted them all together into a pattern, a dramatic creation. Now all was presented as in a film or a play in which one is at the same time actor and infinitely detached spectator. The round table with its surface like dark gleaming ice, its silver and glass, its five-branched Georgian

Circus Boyhood

candlesticks, the faces, the hands, the silent, swift circulating forms of butler and footman, the light clash and clatter, the mingling voices . . . all existed at one remove, yet with a closeness and meaning almost painfully exciting. This element I am perfectly at home in. Now all would unfold itself not haphazard but as it must, with complex inevitability.

This is a recurring feature of Lehmann's novel and it is no surprise that Bill Brandt greatly admired its author. Towards the end of the novel the metaphor for this startling faculty of fixing the fluidity of life becomes explicit: "Something clicked in her head, photographing them . . ."

15 Cocktails in a Surrey garden

16 THE ENGLISH AT HOME Barmaid at the Crooked Billet, Tower Hill

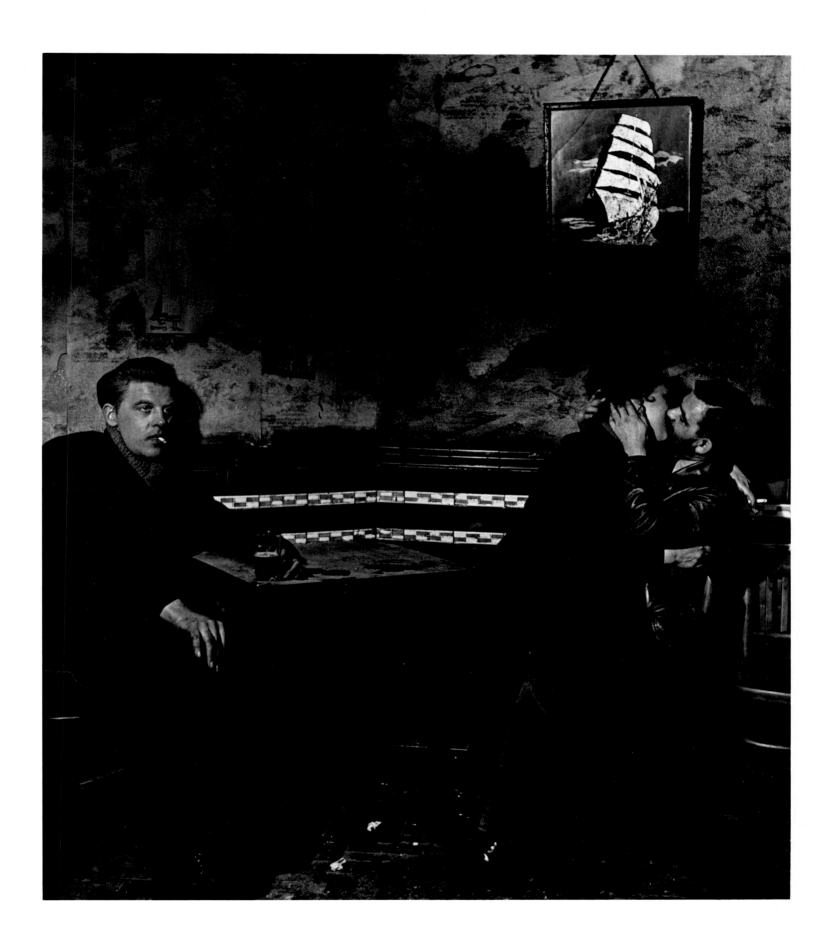

17 At Charlie Brown's

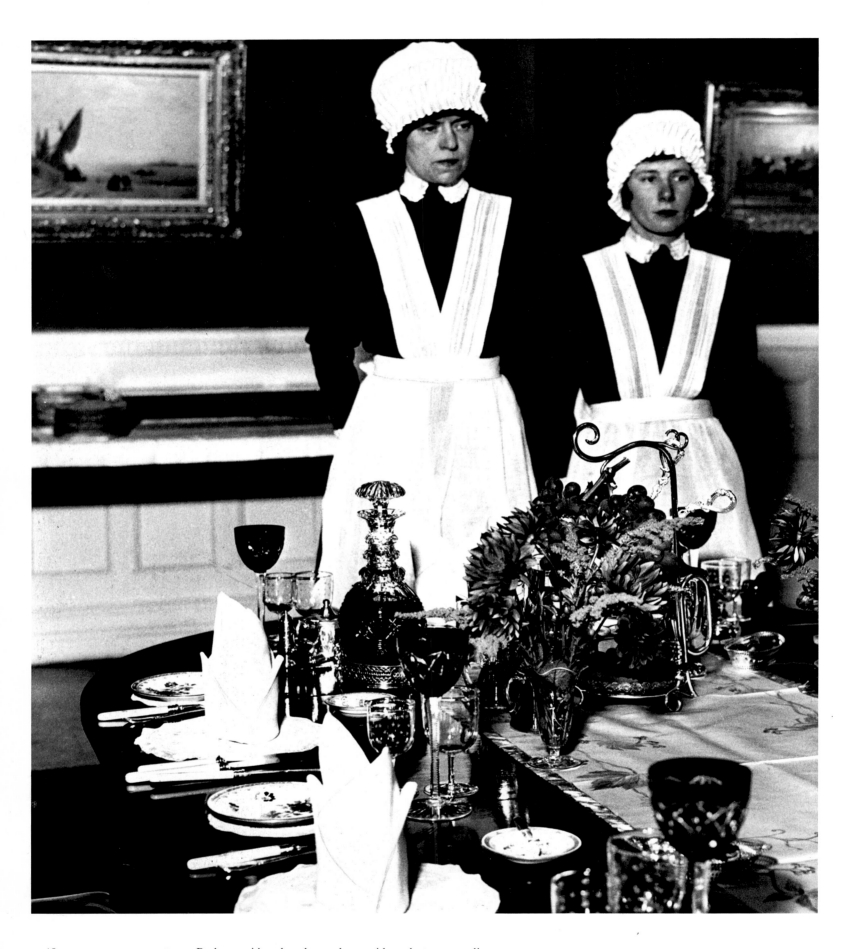

18 THE ENGLISH AT HOME Parlourmaid and under-parlourmaid ready to serve dinner

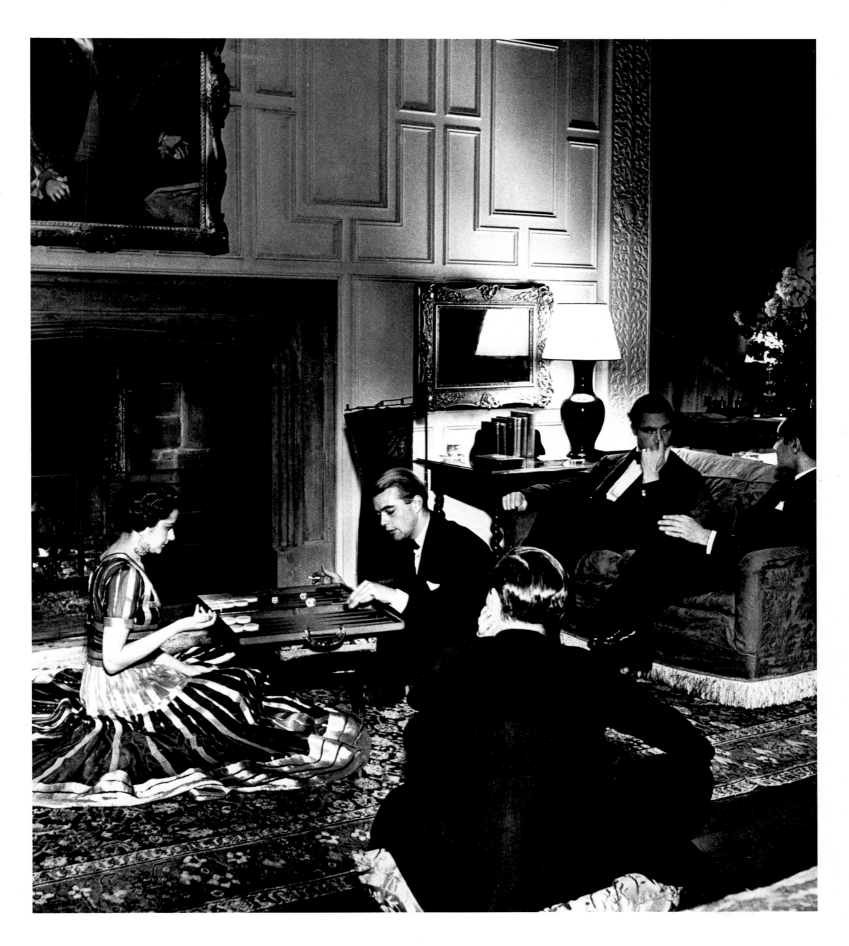

19 Drawing room in Mayfair

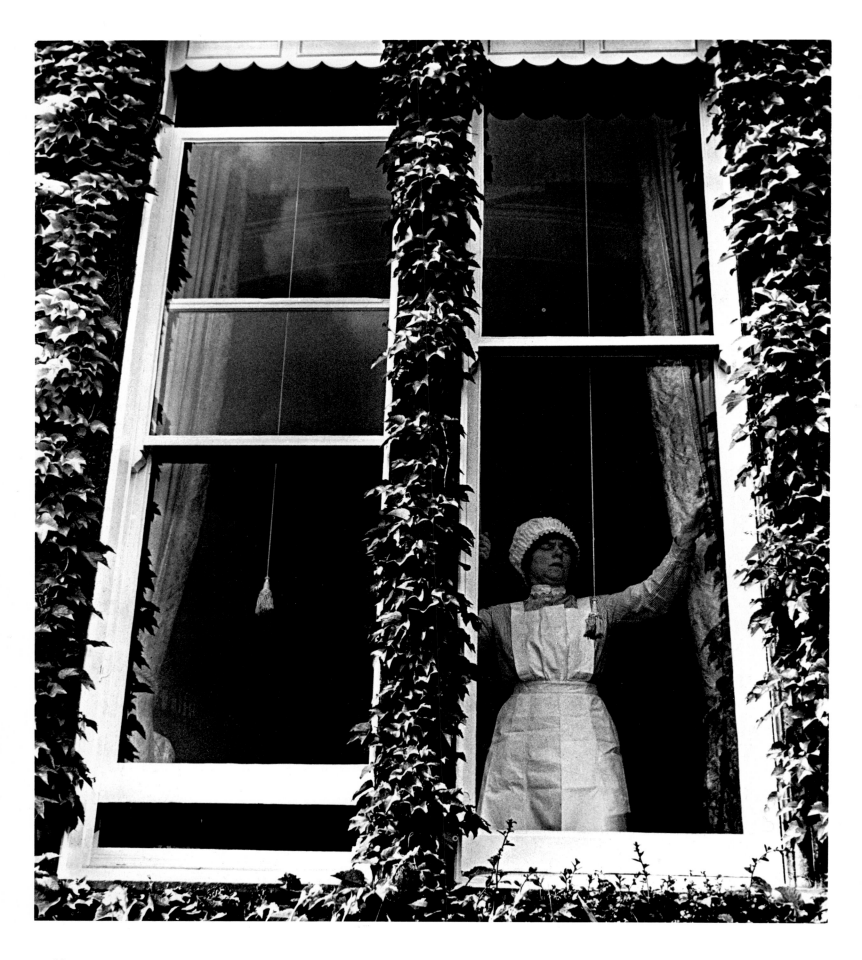

20 THE ENGLISH AT HOME Parlourmaid at a window in Kensington

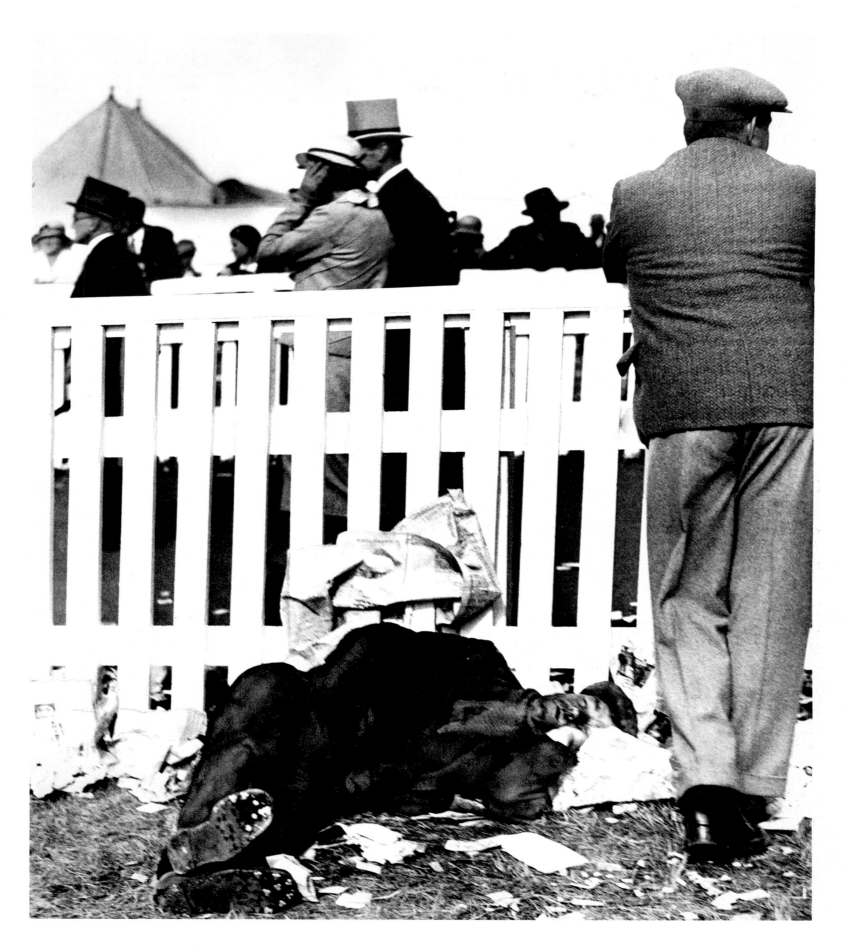

21 Ascot enclosures; within and without

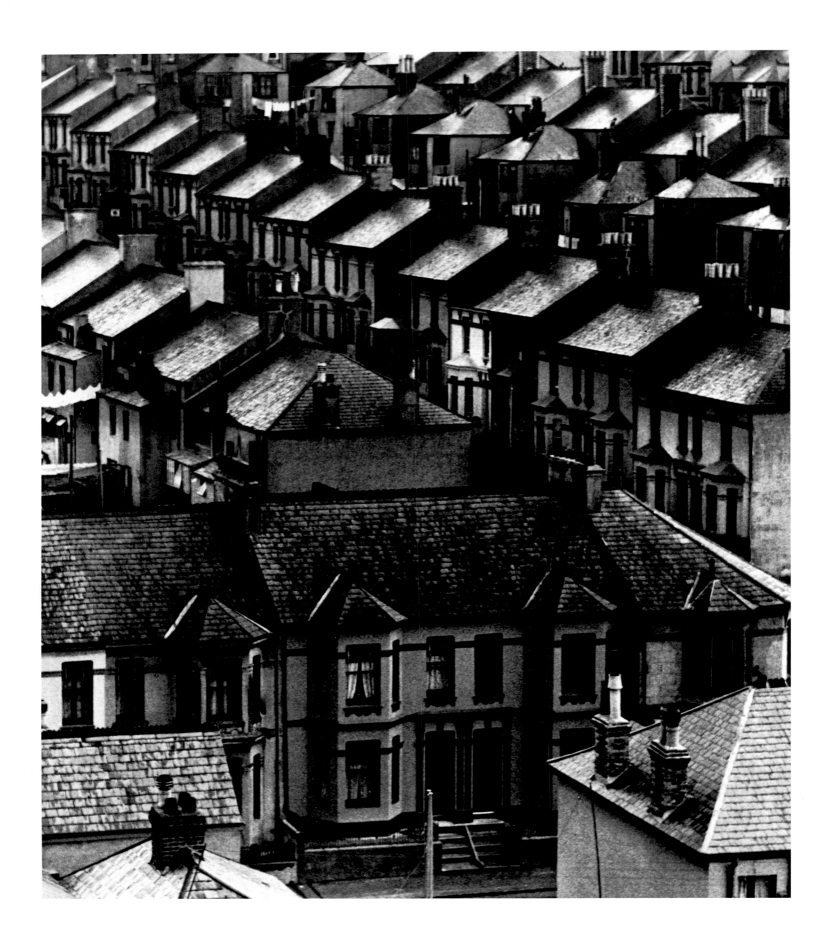

22 THE ENGLISH AT HOME Rainswept roofs

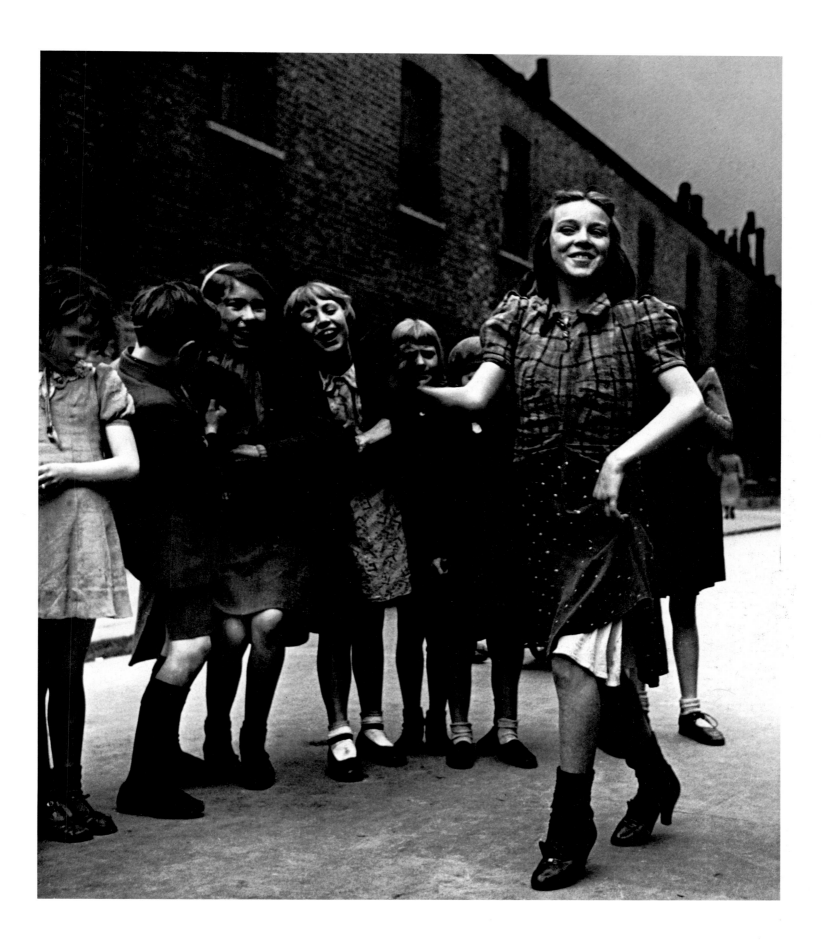

23 East End girl, dancing the Lambeth Walk

A NIGHT IN LONDON

The first book of photographs by Brandt's great contemporary Brassaï was published in 1936. The success of Brassaï's *Paris du Nuit* prompted the publishers Arts et Métiers Graphiques to commission from Bill Brandt a companion volume. *A Night in London* appeared in 1938, with the subtitle, "The story of a London night in 64 photographs by Bill Brandt." The English edition, published by Country Life, was introduced by James Bone, specialist on London and its iconography. In 1937 Bone had introduced to the British public the Danish author Steen Eiler Rasmussen. Rasmussen's book, *London: The Unique City*, owned by Brandt, was at once a detailed and admiring account of the capital and a warning of the social dangers of wholesale modernism in architecture. James Bone noted that Brandt, like Rasmussen, brought a singular, foreign acuity of observation to the subject. He acknowledged that technical developments had brought the nocturnal life of cities within the purview of photography and stressed the prehistory of the subject:

The camera with its sleepless eye under modern lights and with modern equipment is now fitted to record nocturnal London. How Dickens with his instantaneous observation and remembering mind would have welcomed it.

He referred also to the idea of describing London's cycle of activities which dates back at least as far as *Twice Round the Clock; or the Hours of the day and night in London* (with engravings from drawings by W. McConnell), published by the journalist (and associate of Dickens) George Augustus Sala in 1859. Although some subjects remained constant—"Covent Garden before dawn, the Soho restaurants, the man going round the garbage cans, the hansom cab and the sheen of silks and tall hats at the theatre door"— technology had brought a series of new subjects:

Floodlit attics and towers, oiled roadways shining like enamel under the street lights and headlights, the bright lacquer and shining metals of motorcars, illuminated signs, the reflections of strong lamps on the river, searchlights, the bright bare dog arena. A middle aged man can remember a London that had hardly any of these things.

A Night in London was printed in black-and-white photogravure in France to the very high standards of Arts et Métiers Graphiques, whose editor Andre Lejard introduced the French edition *(Londres de nuit)*. Where James Bone had recognized Dickensian antecedents, Lejard's view of London and of Brandt seems to be colored by Baudelaire. The city, especially its East End dockland fringe, was a place of menace and "the indefinable twilit malaise at the edges of big cities" ("ce malaise indéfinissable du crépuscule aux abords

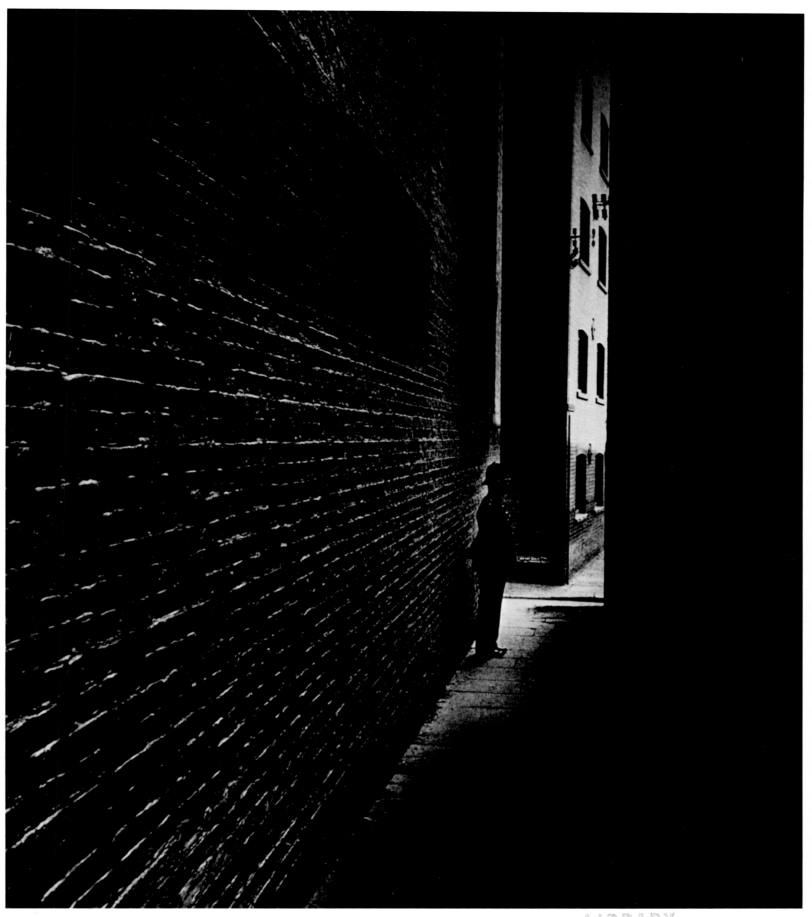

25 Policeman in a dockland alley, Bermondsey

des hautes cites''). Behind Brandt, as an invisible stroller in the night streets, Lejard discerned the ghost of Atget:

> One has the impression that Bill Brandt walked, invisibly, through London for many nights, as Atget did in Paris, letting subjects come to him and, without being aware of it, leaving their traces on his photographic film. It is this that gives to his images their air of strangeness and almost, I would say, indiscretion. At every moment one has the feeling of penetrating an intimacy that is taken unawares and gives itself up defenselessly. Here things and people appear before us like actors in a singular drama that plays itself out beyond any human gaze.

Even now, it is hard to remember Brandt's presence behind the camera when looking at many of the photographs in *A Night in London.* As in *The English at Home,* scenes in the drama were enacted by family and friends and members of their households. Pratt, parlormaid of the banker Henry Brandt, is portrayed preparing a bath in the plate titled ''Madam has a bath.'' In the following plate, madam (Eva, elegantly posed beside a Rolls Royce belonging to one of the uncles) ''leaves for a party.'' In ''8.15: The Curtain Rises'' we see Lili Brandt, the photographer's mother, in a box at the theatre. ''Street Scene'' is acted out by Rolf and Esther Brandt in front of a giant film poster. Side-lighting, presumably from Brandt's photo-floods, casts Rolf Brandt's trilby-ed profile in melodramatic shadow. Three men, played by Rolf and friends, talk in an alley-way somewhere in the East End. As the photograph is about to be taken a policeman appears, by chance, at the end of the alley and becomes part of Brandt's composition. *A Night in London* was, indeed, a ''singular drama,'' precisely because of the exigencies of the photographic medium. Brandt's method was deliberate, his subject and compositions often carefully planned. Sometimes he made preparatory drawings. One of the plates in *A Night in London* is captioned ''At half past ten Mr. and Mrs. Smith prepare for bed.'' An elderly woman in a dressing gown is shown in the foreground, tumbler of water for the bed-side in her hand. A man, seen from the back, is removing his shirt. The photograph is reminiscent of the brothel pictures of Brassaï but Brandt's subject seems to be loneliness, the evening ritual of sleep, and a depressed standard of living. For this photograph he used a professional model for the woman, and a friend played the male role. The subject extends a sense of the night beyond suppositions of villainy and glamour. The idea of the ''directed'' photograph is a commonplace of the present, but it was one of the new modes of photography in the 30's. The whole idea of photography at night is theatrical, as was recognized by Pierre Mac-Orlan in his introduction to the work of Atget in 1930. His words accurately prophesied Brandt's role:

> The elements of the night are the great stage-managers of a social fantasy which is rather simple and always very easy to understand. .. .
> Photography makes use of light to study shade. It reveals the people of the shadows. It is a solar art at the service of night.

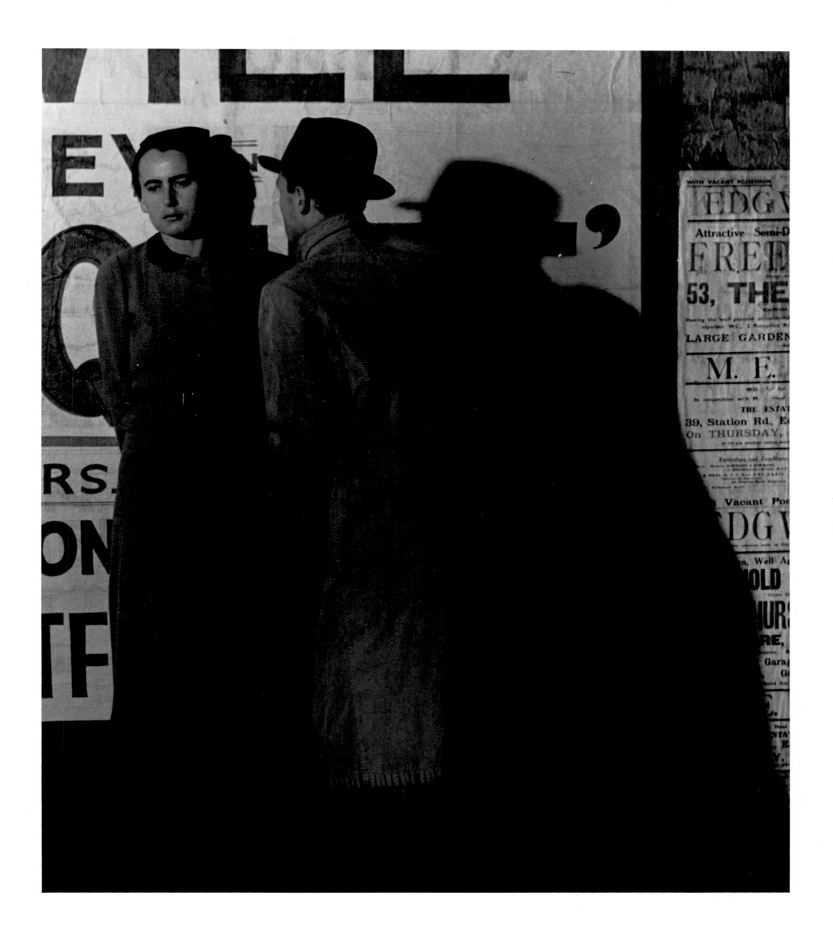

27 Street scene

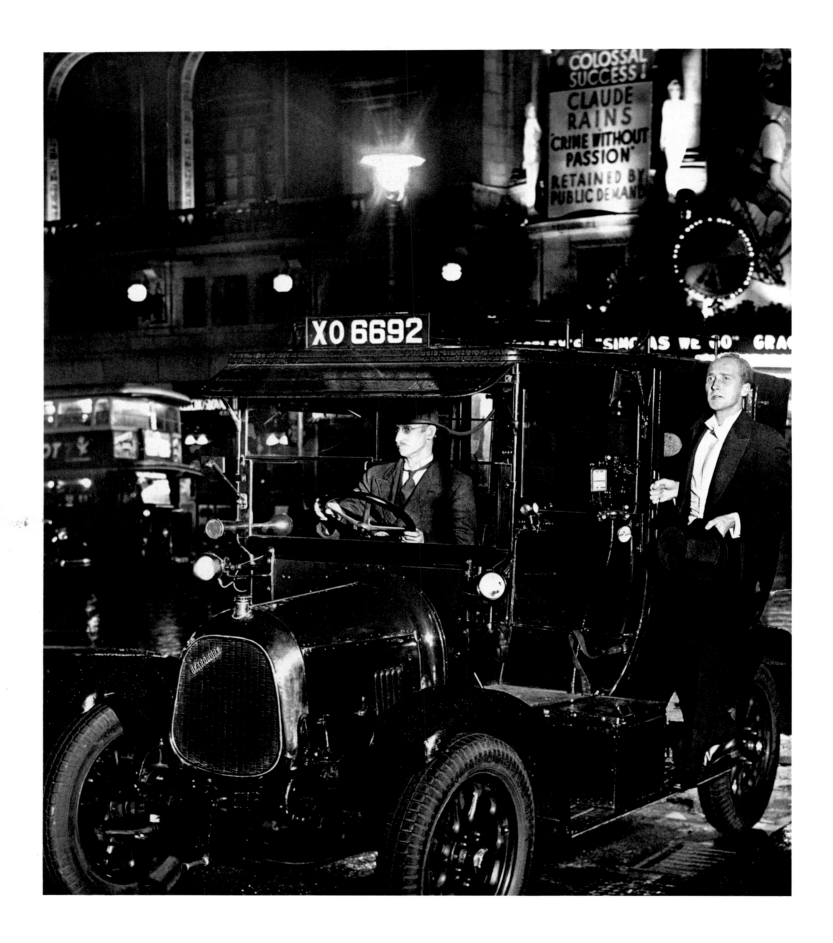

28 A NIGHT IN LONDON After the theatre; taxi in Lower Regent Street

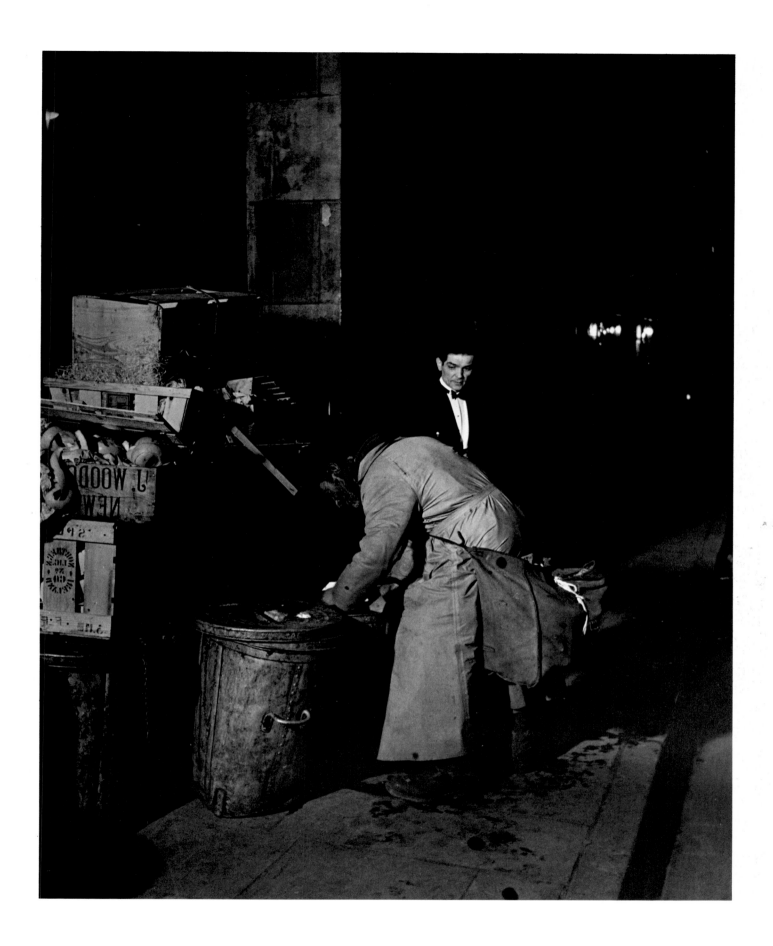

29 Behind the restaurant where the waiters come out for fresh air

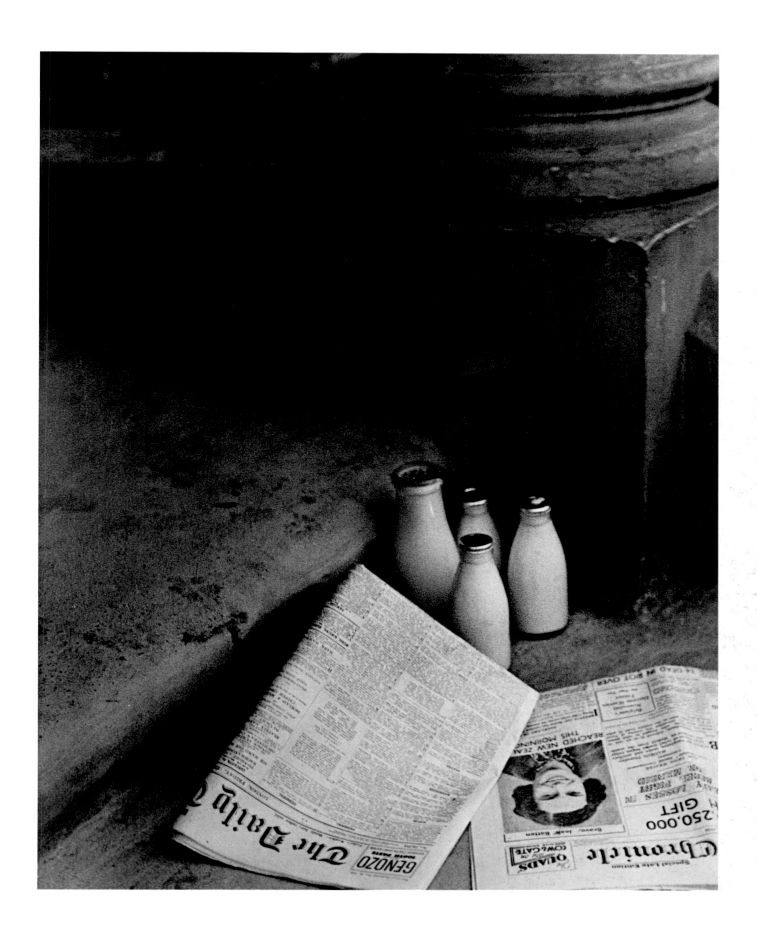

31 Seven o'clock

WARTIME AND ITS AFTERMATH

An important meeting occurred in 1936 when Bill Brandt visited the London offices of the magazine *Weekly Illustrated*. This periodical, the first popular picture magazine in Britain to exploit the new resources of photography, was founded in 1934 by Stefan Lorant. This former editor of the German picture magazine *Münchner Illustrierte Presse* came to England as a refugee from Nazism. At *Weekly Illustrated* Brandt met the young journalist Tom Hopkinson (who was later to be knighted for his services to journalism). Hopkinson had joined the magazine as assistant editor in 1934 and contributed a series of profiles of representative social types, in some ways a literary equivalent to *The English at Home*. He learned about magazine layout and, above all, photography from Stefan Lorant. In his 1982 autobiography *Of This Our Time: A Journalist's Story (1905–50)*, Hopkinson acknowledges that: "Lorant understood photographs as no one else I had ever met understood them. He had been both a still and movie cameraman—he claimed to have been cameraman on Marlene Dietrich's first film—and he thought in pictures not words, appearing to possess a mental record of any photograph he had ever seen and where he saw it." Hopkinson had also come to recognize photography as "a journalistic weapon in its own right, so that if—like myself at that time—you are determined to promote causes and affect conditions, photographs can be a potent means for doing so."

Hopkinson was immediately taken by Brandt, whom he described in the November 1942 issue of *Lilliput*, in the first profile of the photographer ever published. Brandt was "tall and slim, sunburned, with golden hair brushed back. He had a rather narrow mouth with thin lips, long forehead and chin, and very clear blue eyes. He wore a grey flannel suit, had a voice as loud as a moth, and the gentlest manner to be found outside a nunnery." Hopkinson was also taken by *The English at Home* and he arranged for Brandt to study the workings of the magazine for several weeks. While Brandt was photographing *A Night in London* he began to look further afield, and in 1937 he visited the industrial north of England for the first time. Brandt had been moved by the Jarrow Crusade of 1936 and by reading J.B. Priestley's *An English Journey* (1934). Priestley's book described the condition of the industrial northeast where the general effects of the Depression and the closure of ship-building yards led to eighty-percent unemployment: "The whole town looked as if it had entered a perpetual penniless bleak Sabbath. The men wore the drawn masks of prisoners of war."

Brandt photographed in Jarrow, in the coalfields, Newcastle, Halifax—where the dark satanic mills stood idle—and in the Potteries of Staffordshire. His photographs are the visual equivalents of the passionate literary reporting of Priestley and George Orwell and, behind them, the Dickens who described "Coketown" in *Hard Times*. A decade was to pass before these photographs were published.

It was now, ten years after becoming a photographer, that Bill Brandt became a photojournalist in regular demand by magazines. For the next decade he worked at full stretch on commissions for the picture press and also from the British government. His major markets were *Lilliput*, founded by Lorant in 1937, *Picture Post*, founded—again by Lorant—the following year, and the English and American editions of *Harper's Bazaar*. By January 1940 *Lilliput* was selling 300,000 copies a month and *Picture Post* moved towards a million and a half copies a week. Tom Hopkinson was his editor at both *Picture Post* and *Lilliput*.

A Night in London had ended on a note of warning. The final plate shows milk and daily newspapers delivered to a London doorstep. This note of domestic ritual is not left undisturbed. The copy of *The News Chronicle* is folded back so that we can read a headline (from 1936): Heavy Losses in Rebel Fight for Madrid. After the Munich Agreement of September 1938, the appeasement policies of Prime Minister Chamberlain so outraged Brandt that, for the first and apparently last time, he marched in a London demonstration. In September 1939 he photographed the moonlit vacancy of London's blackout. In the autumn of 1940 he was commissioned by the Home Office to record conditions in the London air-raid shelters. Each evening he was given an itinerary of shelters to photograph, sometimes as many as five in one night. Two Underground Station shelters were selected—Elephant and Castle, and

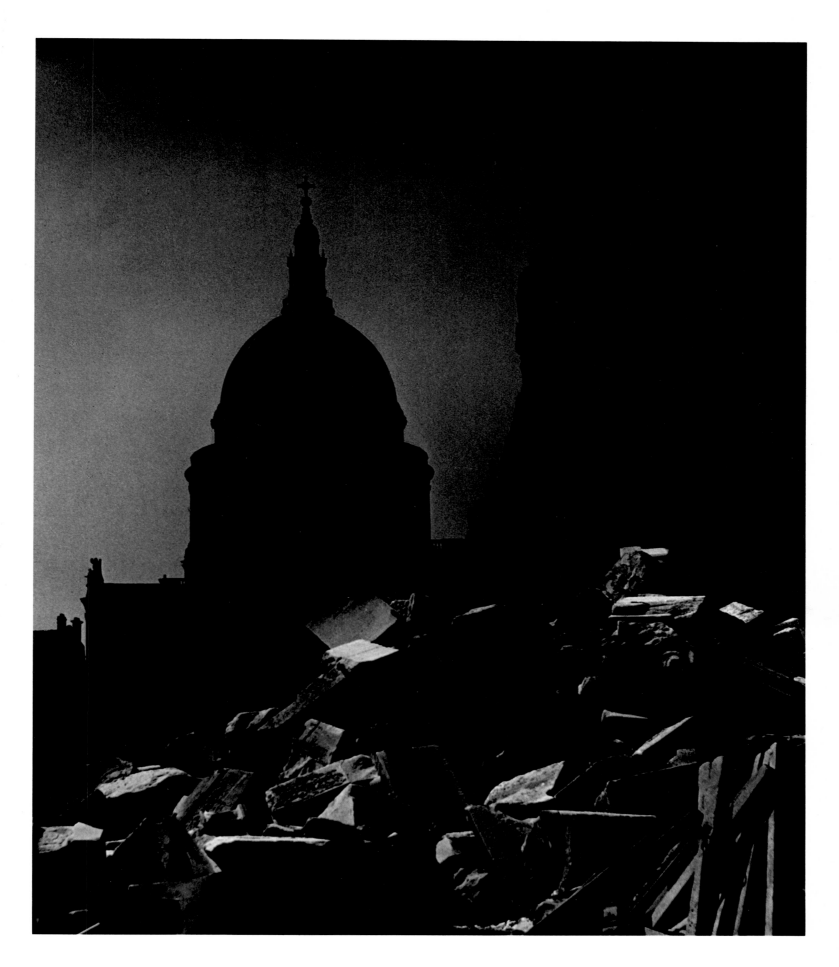

33 St. Paul's Cathedral in the moonlight

*But London does change. Out of the ruins of the Great Fire rose the buildings of Wren.
And London has changed more rapidly than ever in the last few years. The London of
the last war was a different place from the London of 1938. The glamorous make-up of
the world's largest city faded with the lights. Under the soft light of the moon the
blacked-out town had a new beauty. The houses looked flat like painted scenery and
the bombed ruins made strangely shaped silhouettes. Through the gaps new vistas were
opened and for the first time the Londoner caught the full view of St. Pauls.*

BILL BRANDT, *Camera in London*, 1948

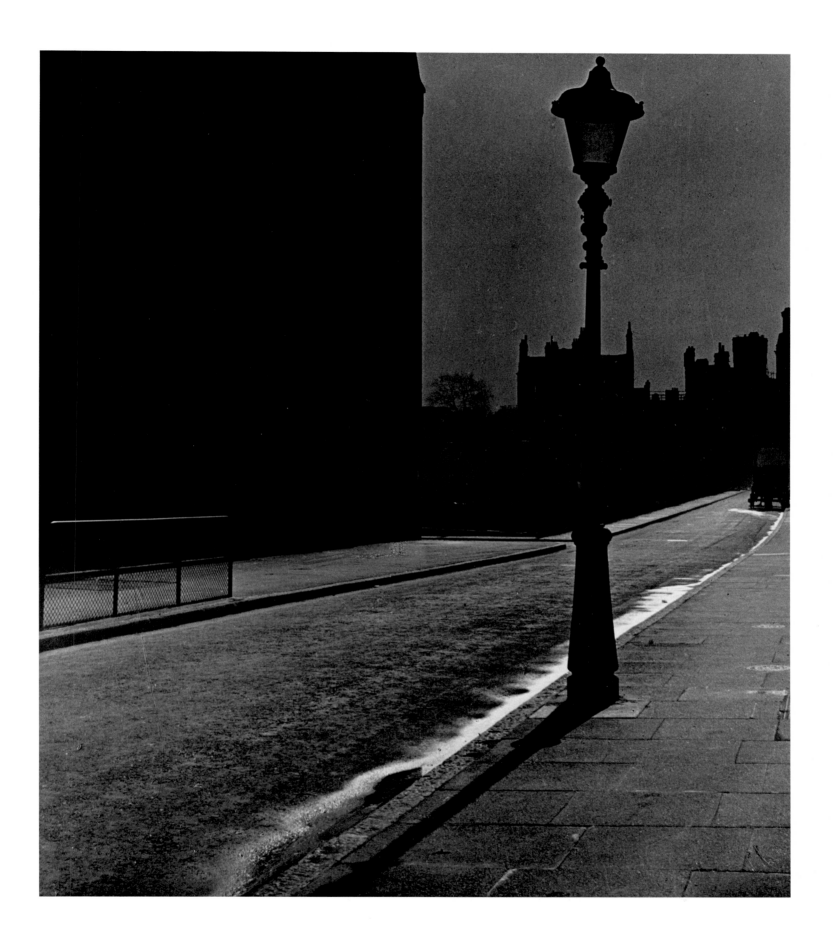

35 Deserted street in bombed Bloomsbury

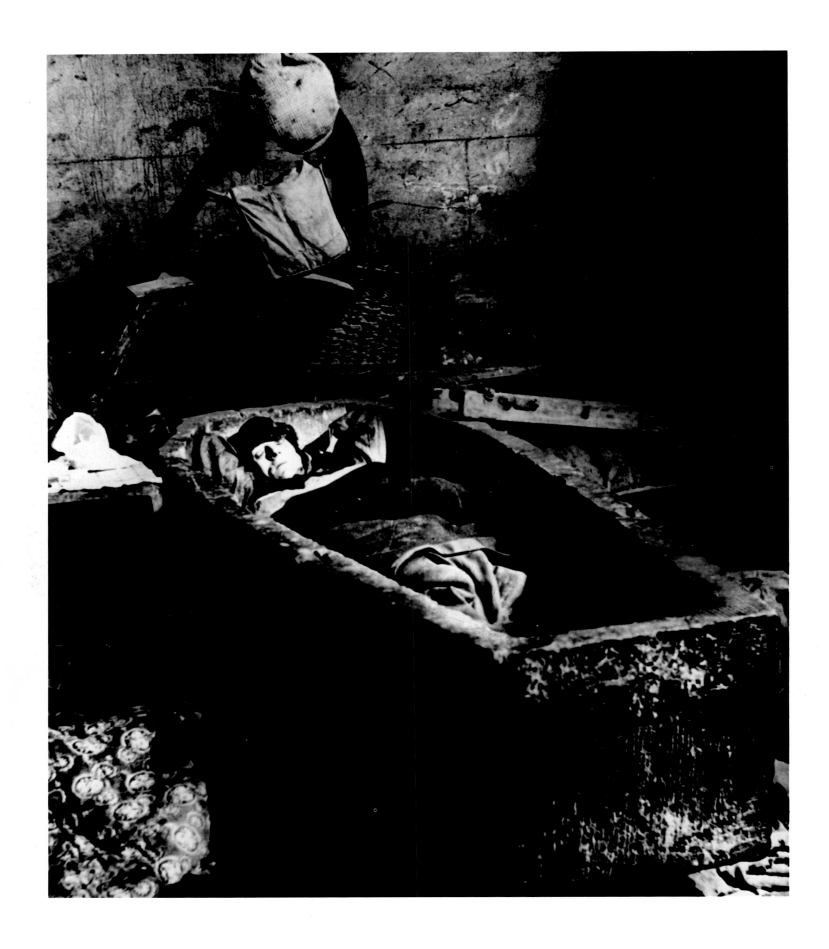

36 WARTIME AND ITS AFTERMATH Asleep in a sarcophagus in Christ Church, Spitalfields

Liverpool Street. The other shelters photographed were Church crypts, and the improvised protection offered by the basements of a bookshop, a garage and a wine merchant. Brandt later recalled the eerie silence of the shelters in contrast to the noise of bombardment overhead and "the long alley of intermingled bodies, with the hot, smelly air and continual murmur of snores." During an official visit to Britian in late 1940, Wendell Wilkie was given a complete set of Brandt's shelter photographs to take back to President Roosevelt. Brandt's shelter photographs were published by Cyril Connolly in *Horizon,* the leading cultural magazine of the day, in February 1942. " 'Elephant and Castle Station 3:45 a.m.', eternalizes for me the dreamlike monotony of wartime London," Connolly wrote long afterwards. *Lilliput* published the photographs alongside the shelter drawings of Henry Moore in December 1942. Brandt's parents came to England in 1939 and settled at Crawley Down, Sussex. His father, L.W. Brandt, began to acquire works of art by members of the English avant-garde—Moore, Graham Sutherland and John Piper—who were much admired by his son. Brandt would later base his photograph of the great Romantic landscape of Gordale Scar on a Piper painting in his father's collection. Returning to London after Christmas celebrations in Sussex on December 29, 1940, Brandt's train had to halt some distance short of London Bridge Station because of a massive incendiary bomb attack. Brandt found himself separated from the other passengers and alone in the raid among flaming buildings. This terrifying experience may have caused the onset of diabetes from which he suffered for the rest of his life. At *Lilliput* Brandt often himself suggested, and accepted, assignments he wished to pursue; and he usually chose and sequenced his own photographs for publication. *Picture Post* commissioned more routine subjects of the time: the Army Suitability Test, the Stirling Bomber, Fire Guards on the House of Commons. As is the way with the picture press, many of these stories by Brandt remained unpublished. *Harper's Bazaar* commissioned portraits of society figures, country houses and fashion.

Brandt collected examples of his work from the 30's and 40's together in 1948 under the title *Camera in London,* his third book. Few can have known the city so thoroughly or intimately. He wrote in the introduction—which is his fullest essay on London and on photography—that "it would take a library of picture books to show London's many moods—and then the photographer would probably have missed that side street in Islington where each house has a graven sphinx beside its entrance." Brandt's great photographs of the decade are often close in feeling to the prose interpretations of London in wartime by Elizabeth Bowen, a writer whom he knew and greatly admired. His elegant and sympathetic

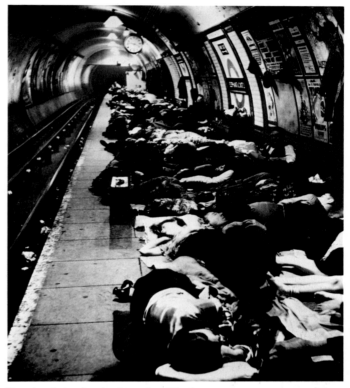

People sheltering in the tube, Elephant and Castle underground station

portrait of the novelist appeared in American *Harper's Bazaar,* beside her story "Mysterious Kor" in April 1946. The story opens:

Full moon drenched the city and searched it; there was not a niche left to stand in. The effect was remorseless: London looked like the moon's capital—shallow, cratered, extinct. It was late, but not yet midnight; now the buses had stopped; the polished roads and streets in this region sent for minutes together a ghostly unbroken reflection up. . . .
And the moon did more: it exonerated and beautified. . . .

38 WARTIME AND ITS AFTERMATH Train leaving Newcastle

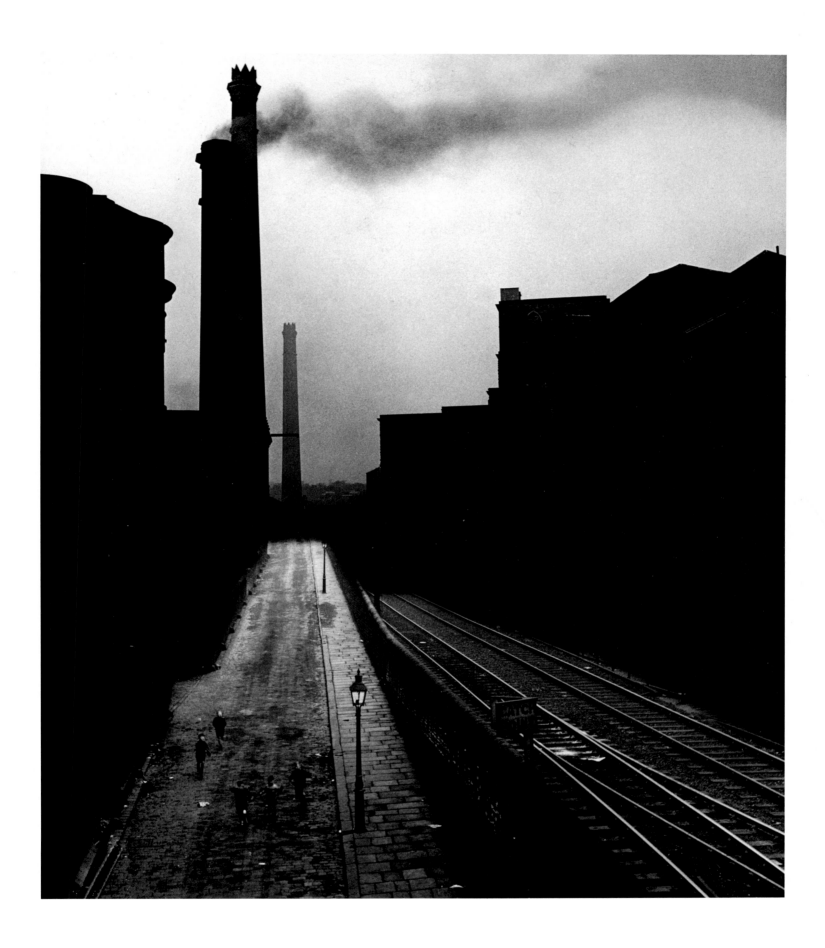

PORTRAITS

Ezra Pound, 1928

Although Bill Brandt's career began, decisively, with his close-up portrait of Ezra Pound in 1928, his subject in the 30's was the social portrait and the urban setting. An exception is a dramatic head of his brother Rolf, lit in the style of expressionist cinema, from the mid-30's. Brandt's portraiture flowered in the 40's. Its hallmarks are seriousness, reticence and, despite some spectacular exceptions, a circumambience perhaps best described in the words of Elizabeth Bowen: "a tense bright dusk." Brandt portrayed artists and thinkers thoughtfully and in isolation. He rarely photographed politicians or businessmen. It is possible that as a young man in Vienna he may have known something of the activities of the art historian Heinrich Schwarz (of the Küpferstich Kabinett), who was then in the midst of his exciting rediscovery of the calotypes of Hill and Adamson from the 1840's. The appearance of Brandt's photograph of *Caledonian Market* (1929) in the pages of *Das Deutches Lichtbild* in 1932 coincided with the publication in the same volume of an article by the Austrian art photographer Heinrich Kühn titled "The Photographic Mastery of Extreme Light and Shade." Kühn argued for manipulation of chiaroscuro in the interests of expression. The human eye, he wrote, is constructed in such a way that "high lights always become blended with shadows and . . . the action of the iris and other physiological processes co-operate to bring extreme contrasts closer together." Such physiological processes must be understood by "real photographers, who know how to portray atmosphere and mood convincingly and who have a message to deliver to the soul of man." Kühn opposed a photography which offered merely mechanical renderings of tone gradations. He celebrated instead the achievements of David Octavius Hill, whose "powerful expressionism of the Talbotype/Calotype . . . led him to the decisively characteristic outline of draughtsmanship." Brandt contrived, in his portrait of E.M. Forster (1947), something of the shadowed luxuriance of calotype and later wrote of his intentions in *Camera in London* (1948):

> When photographing a writer, I was forcibly impressed by the Victorian character of the room in which he sat. A hard print brought out this impression. Details were lost as they were in early Victorian photographs. My print did not imitate those old photographs; the methods of printing simply formed a link of association between the two, adding its reminiscent effect to the Victorian setting.

In this period Brandt consistently used the Rolleiflex camera which emerged on the photographic scene along with Brandt in 1928. The camera's ground-glass provided a clear view of the subject and the 2¼ x 2¼-inch negative gave Brandt the latitude he required for darkroom work. Brandt intensified or lightened his prints, cropped and retouched—sometimes drastically—and

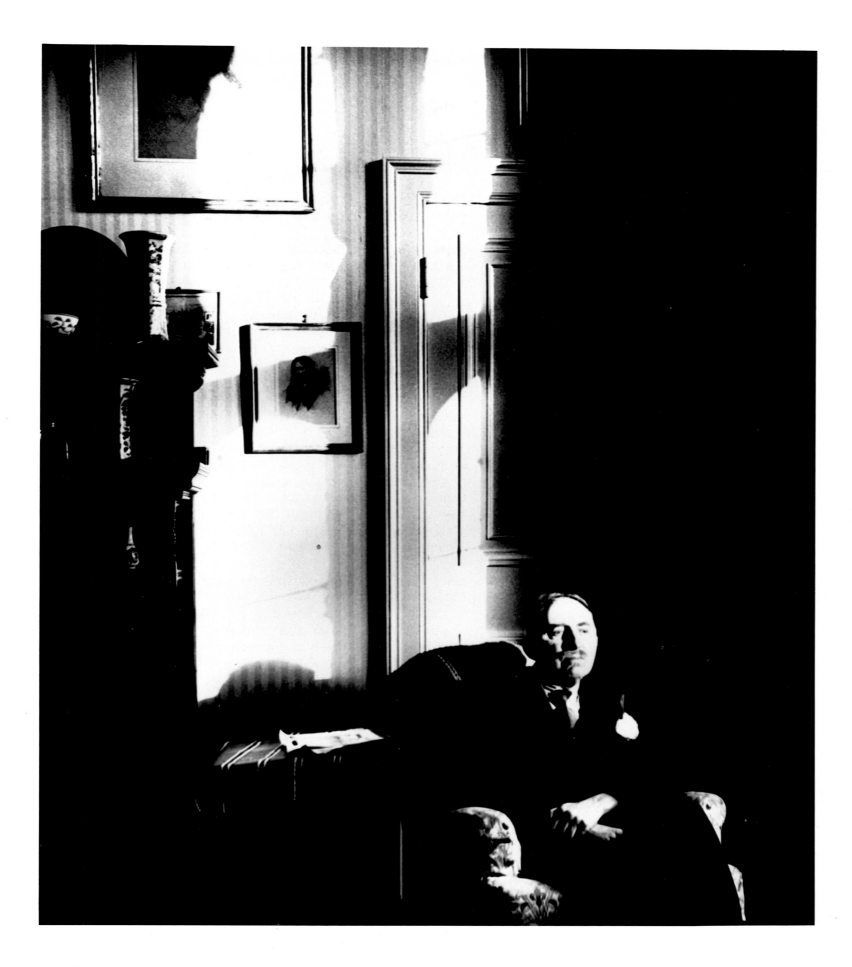

41 E. M. Forster, 1947

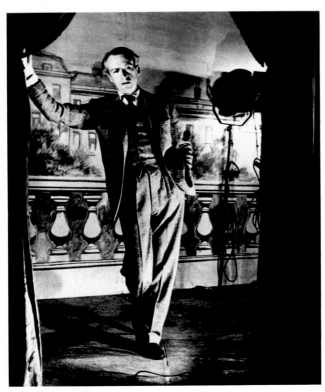

Cecil Beaton, 1945

experimented tirelessly to achieve the veiled chiaroscuro tones typical of his photographs at this time. His serious portraiture began with a feature for *Lilliput* in December 1941. "Young Poets of Democracy," with text by Stephen Spender, presented Brandt's new portraits of Spender, C. Day Lewis, Dylan Thomas, Louis MacNeice, Alun Lewis, Anne Ridler, Laurie Lee and William Empson—representatives of both the Auden Generation and the poets in reaction to them, whom Cyril Connolly named the "new romantics." Brandt and his wife Eva, who published a remarkable novel called *The Mermaids* in 1956, regularly read John Lehmann's *New Writing*. Tom Hopkinson kept them in touch with interesting developments elsewhere, notably in *Horizon* where his own stories were achieving acclaim. Composers were photographed in 1946 and visual artists in 1948. In November 1949, *Lilliput* published "A Gallery of Literary Artists": E.M. Forster, Norman Douglas, Ivy Compton-Burnett, Robert Graves, Edith and Osbert Sitwell, Elizabeth Bowen, Evelyn Waugh and Graham Greene. Brandt's portrait series for *Lilliput* closed in November 1949 with "The Box Office Boys"—the theatre producers of London's West End. This was an unlikely subject for him but times were changing. This phase of his portraiture came suddenly to an end when, in October 1949, Tom Hopkinson was forced out of the editorship of *Picture Post*. Many years later Sir Tom Hopkinson, as he became, speaking of the photojournalist Donald McCullin, said that a photographer of this caliber was akin to a thoroughbred racehorse and should be handled with great sensitivity by the responsible editor. As Bill Brandt's editor, Hopkinson always used another "thoroughbred" with discernment. At American *Harper's Bazaar,* the editor Carmel Snow gave Brandt similar encouragement and support in the later 40's and into the 50's. Brandt's early portraiture omits one individual, not exactly a writer and not usually described as a visual artist, whose oeuvre seems to have some say in the amply shadowed apartments in which we find so many of Brandt's sitters. In 1982 the present writer noted the omission in conversation with Bill Brandt: "Ah, Hitchcock, I would love to have photographed him. It could never be arranged. I had even chosen the exact spot. It was to have been at Charing Cross Underground Station. There is an amazingly long empty corridor that looks as if it goes right under the river. That is where I wanted to photograph him."

A second and distinct period of portrait photography began in the late 50's. Brandt's later portrait interpretations are expressed through the use of the Superwide Hasselblad. The 90° angle of the lens was exactly right for Brandt's portrait interiors. For outdoor pictures it allowed Brandt to calculate the composition of his three-quarter length study of Francis Bacon and to include the sweeping lamp-lit perspective of Primrose Hill in Camden Town, London. The high-energy vanishing lines and the high-contrast printing style Brandt then adopted gave the later portraits an abrasive edge dissimilar to the earlier portraits and highly typical of the 60's. Brandt continued to take portrait assignments until 1981 and in that year added a final series to the pantheon of the creative individuals he particularly admired.

43 Graham Greene, 1948

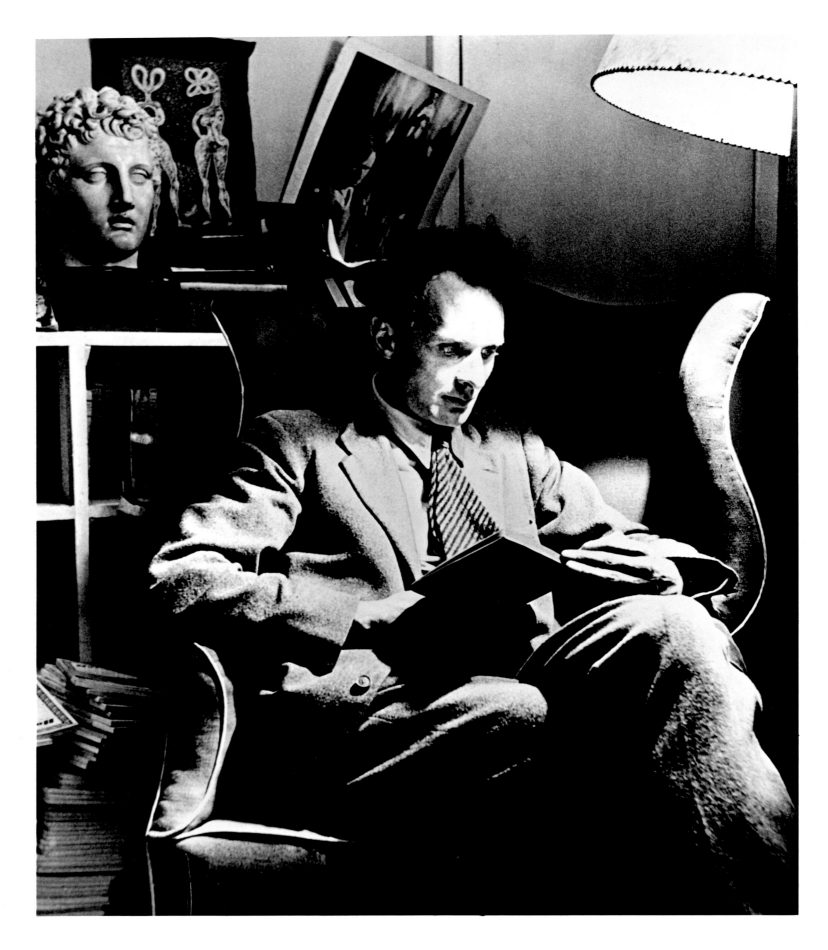

44 PORTRAITS Stephen Spender, 1941

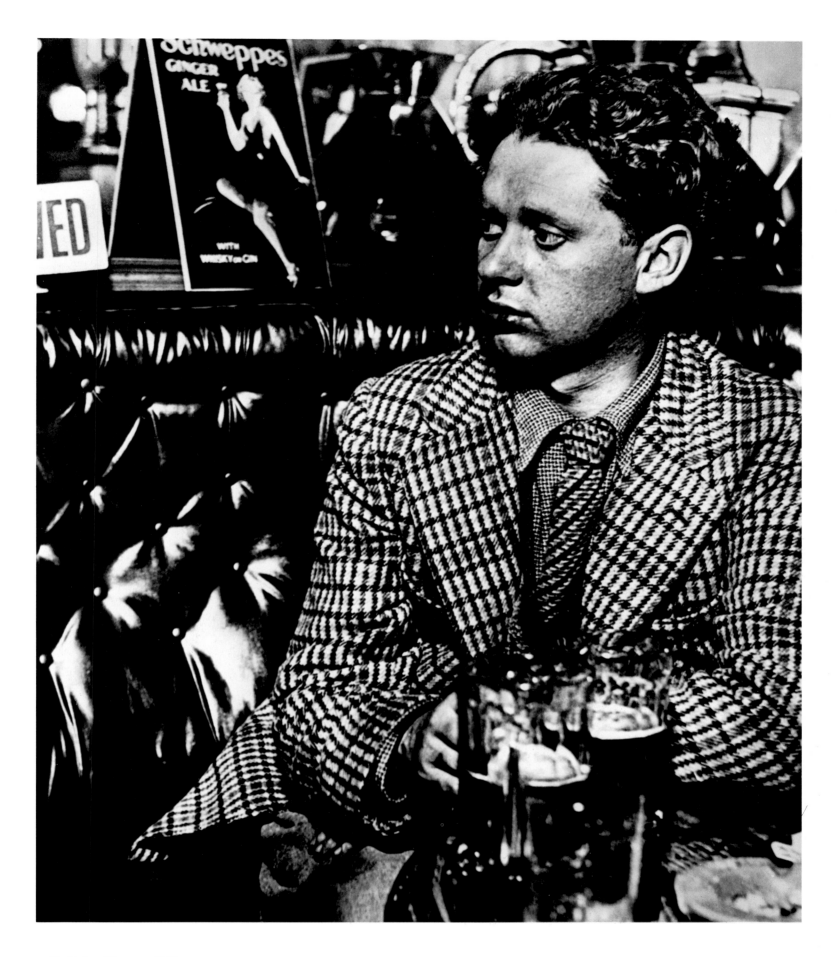

45 Dylan Thomas, 1941

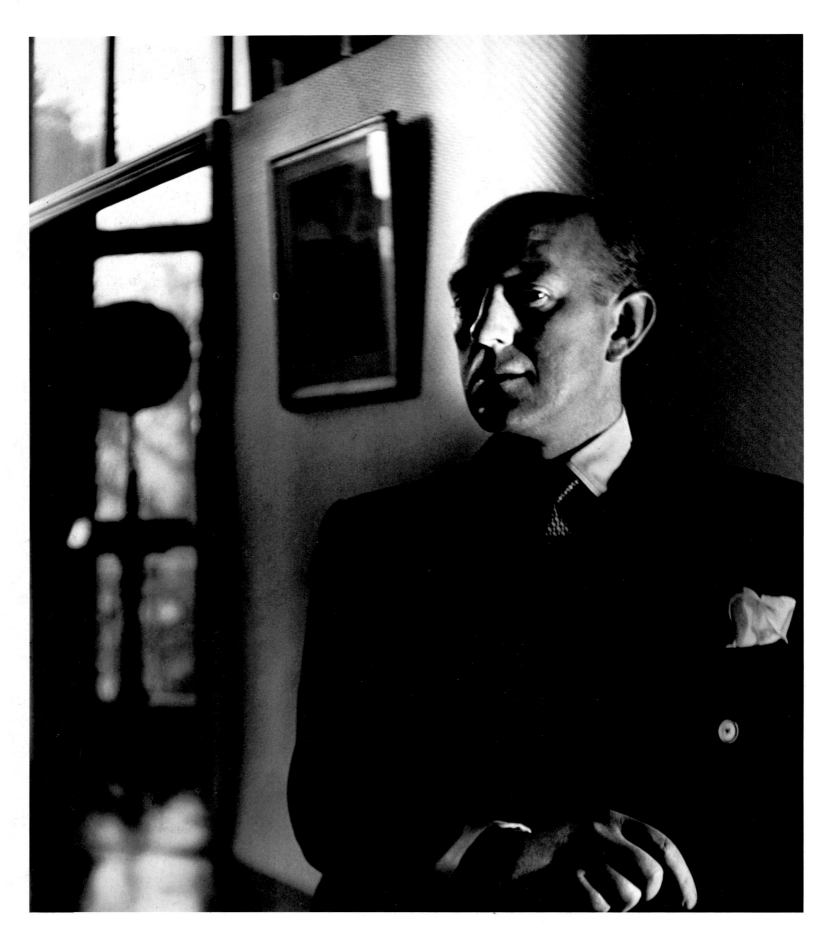

46 PORTRAITS Alec Guinness, 1952

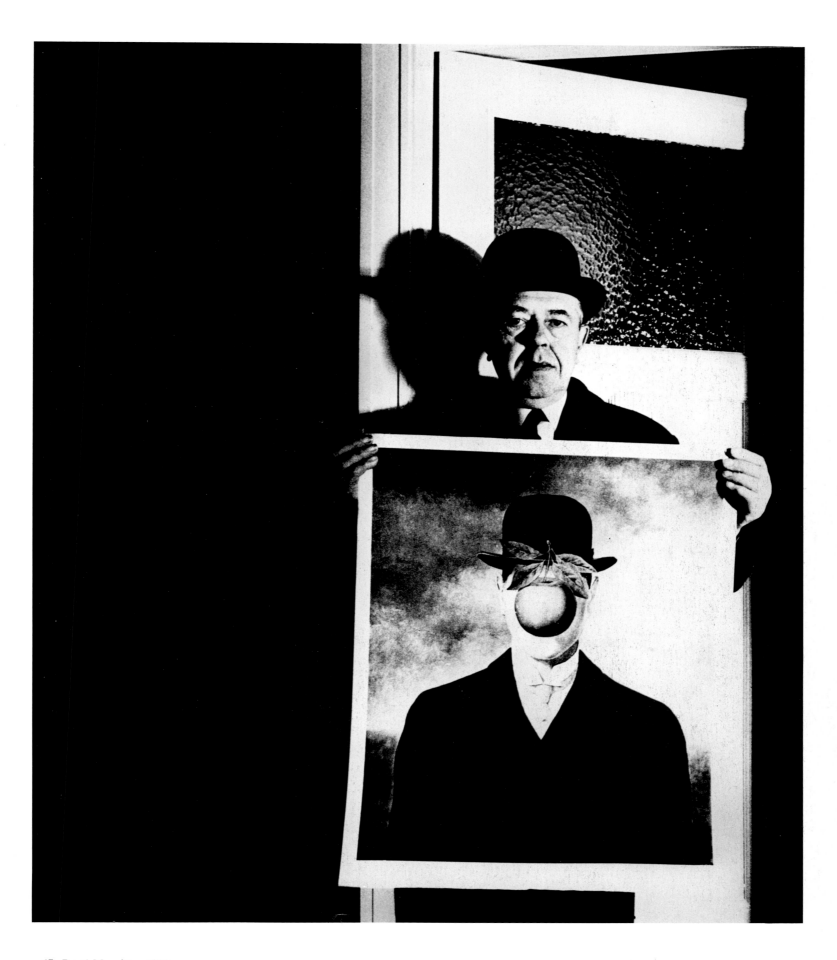

47 René Magritte, 1966

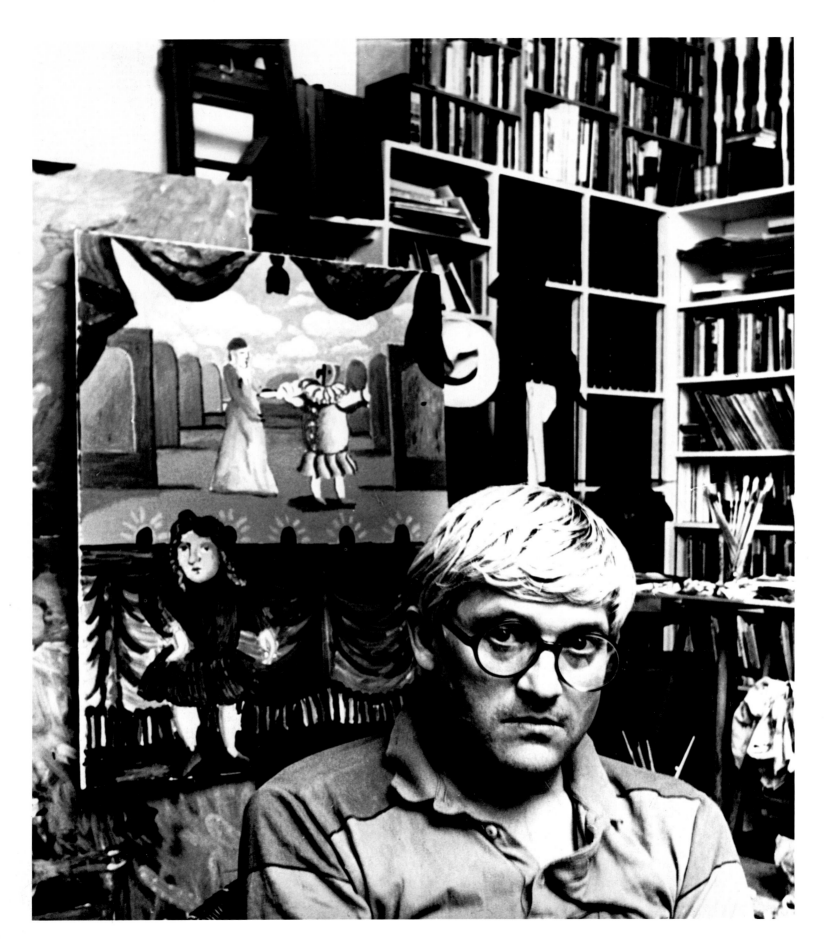

48 PORTRAITS David Hockney, 1980

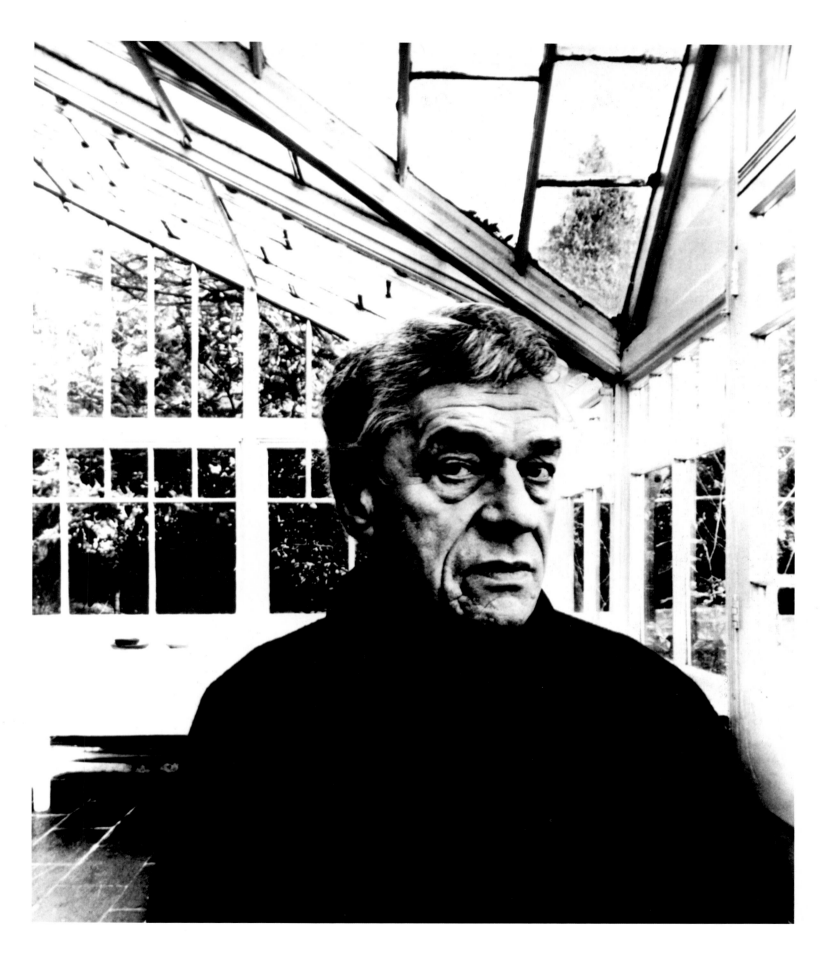

49 Paul Scofield, 1981

Thus it was I found atmosphere *to be the spell that charged the commonplace with beauty. And still I am not sure what atmosphere is. I should be hard put to define it. I only know it is a combination of elements, perhaps most simply and yet most inadequately described in terms of lighting and viewpoint, which reveals the subject as familiar and yet strange.*

I may want to convey an impression of the loneliness of a human figure in an outdoor scene. Taking that figure close to the camera and on a path stretching away behind him to a distant horizon intensifies the effect of solitude.

BILL BRANDT, *Camera in London,* 1948

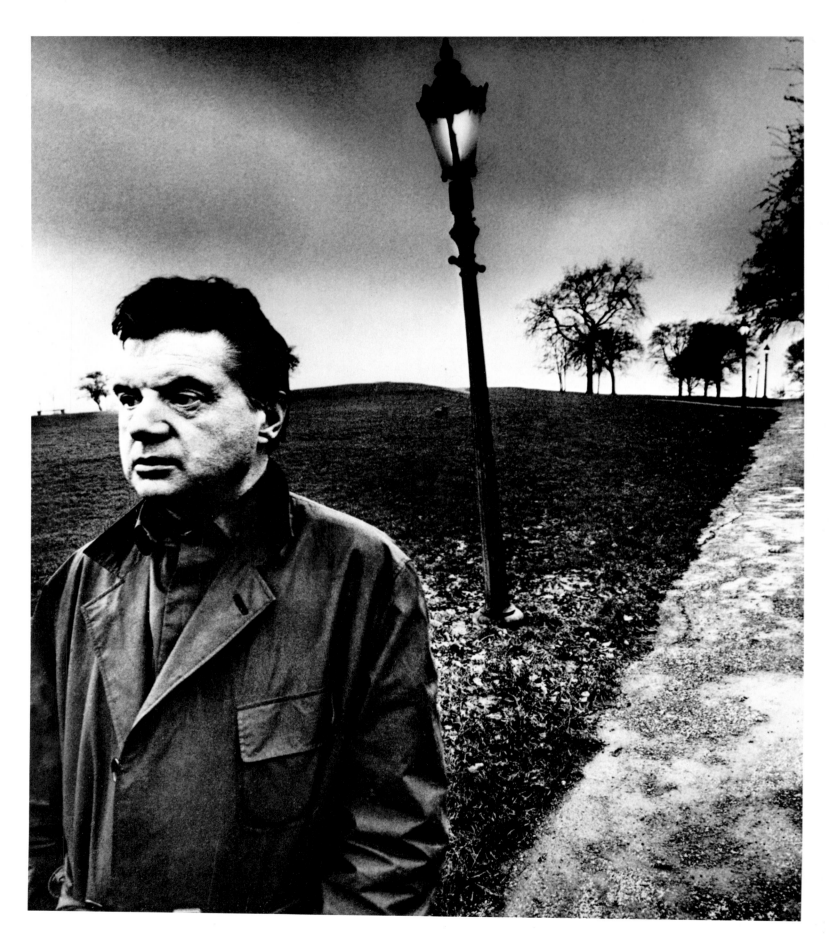

51 Francis Bacon, 1963

LITERARY BRITAIN

“**B**ill Brandt is one of those photographers whose work falls naturally into 'periods.' He cannot take a photograph unless obsessed by a particular pictorial vision, often worked out to the smallest detail . . . Those 'periods' seem to last, as a rule, about five years.'' So wrote Tom Hopkinson on the subject of Brandt's landscapes in 1954. Although Bill Brandt was capable of undertaking a whole range of assignments during his decade as a photojournalist, it is also true that the five years from 1945 to 1950 saw the production of his interpretation of British landscape. The finest results of this exploration were published in book form, as *Literary Britain,* in 1951. He read, admired and thought carefully about the writings and setting of the Brontë sisters, Thomas Hardy, George Crabbe, and John Clare, some of whose poems he knew by heart. These and other literary landscapes were photographed for *Lilliput* between 1945 and 1948. Other subjects were added from *Picture Post* and *Harper's Bazaar* assignments. This material interlocks with his portraits of contemporary writers, amounting to a series of posthumous portraits—in the form of landscape—of literary ancestors. Brandt shared in Britain's general return to the classics—particularly those of the nineteenth century—which occurred in the years under threat by war. Suspended social life, long railway journeys and the need to reaffirm ideas of native identity contributed to this turn on the part of the British public. At this period, too, Brandt began to interest himself in the rediscovery of Victorian furnishings and objets d'art such as characterized his later apartment.

Brandt's vision of landscape shares many features with the sensibility, at once modern and deeply traditional, that was expressed in the contemporaneous paintings of Graham Sutherland, Paul Nash and John Piper; the music of Benjamin Britten; and the writings of the new romantic poets. Writers were at once attracted and impressed by Brandt's literary landscapes. Although he never met Brandt, the novelist Lawrence Durrell attempted to persuade the leading poetry publishers, Faber and Faber, to publish Brandt's landscapes in book form. In 1950, Desmond Flower of Cassell & Co. commissioned Brandt to complete his series.

Introduced by the leading man of letters, John Hayward, *Literary Britain* was received with acclaim by writers well qualified to judge it: Geoffrey Grigson, John Betjeman, Lawrence Durrell, and the unfailing Tom Hopkinson. Brandt's deep immersion in the subject and his ability to reflect the spirit of the writings he admired was echoed by the translation of his visual imagery back into the language of poetry — so, in any case, it seems when we think of Brandt's 1947 masterpiece, taken on midsummer's night on the Isle of Skye, and read these lines composed by Louis MacNeice:

. . . a wild nest
Further, more truly west, on a bare height
Where nothing need be useful and the breakers
Came and came but never made any progress
And children were reborn each night.
—*Day of Renewal* (1950–51)

53 Isle of Skye; after James Boswell

54 LITERARY BRITAIN Barbary Castle, Marlborough Downs; after Richard Jefferies

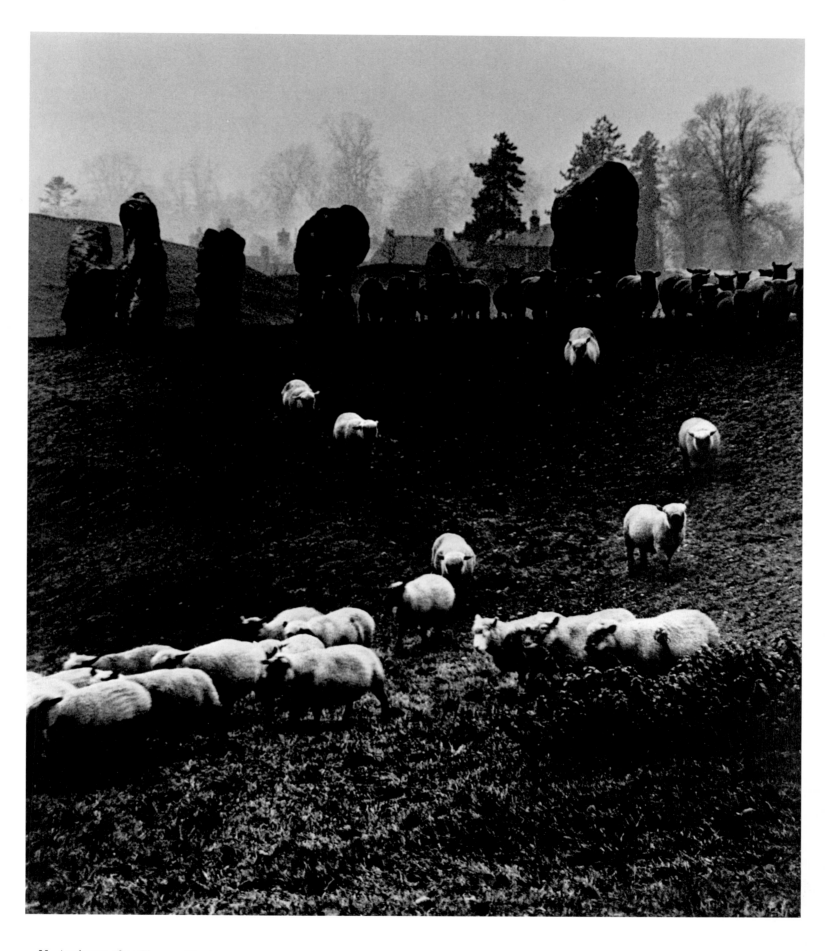

55 Avebury; after Thomas Hardy

*In the background is the sofa on which Emily died.
Above it is a painting of the girl's father. The trunk is the
same one which Charlotte and Emily packed with such
excitement before the trip to Brussels.*
 "The Brontës," from *Literary Britain*, 1951

57 In Haworth Parsonage; after the Brontës

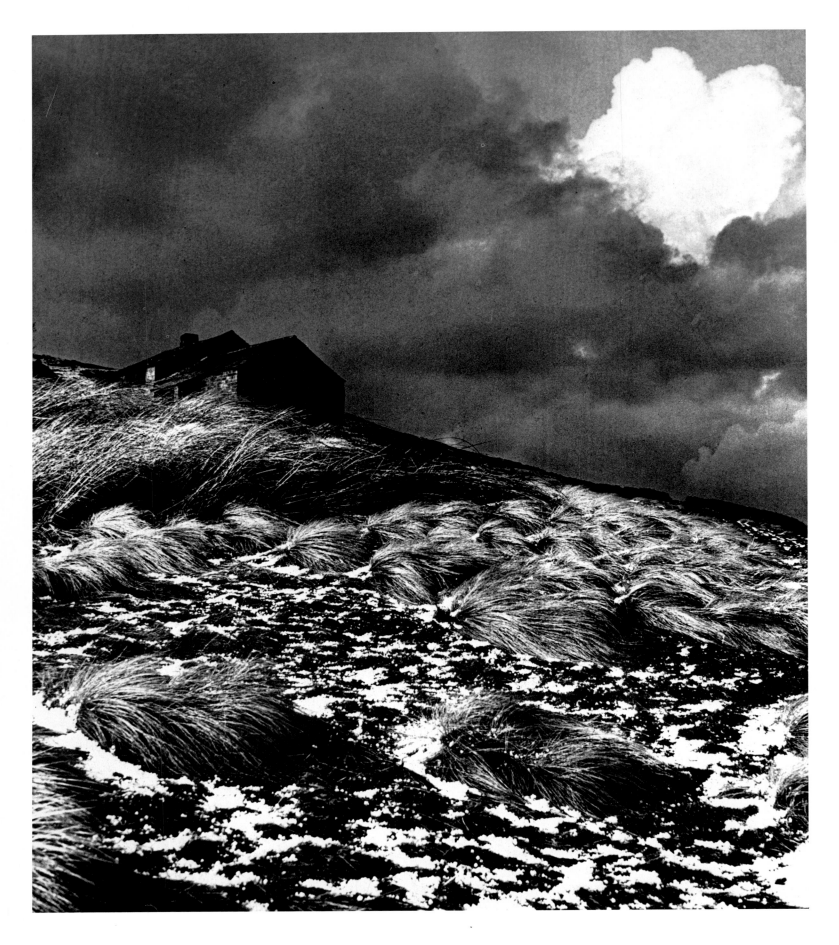

58 LITERARY BRITAIN Withens; after Emily Brontë

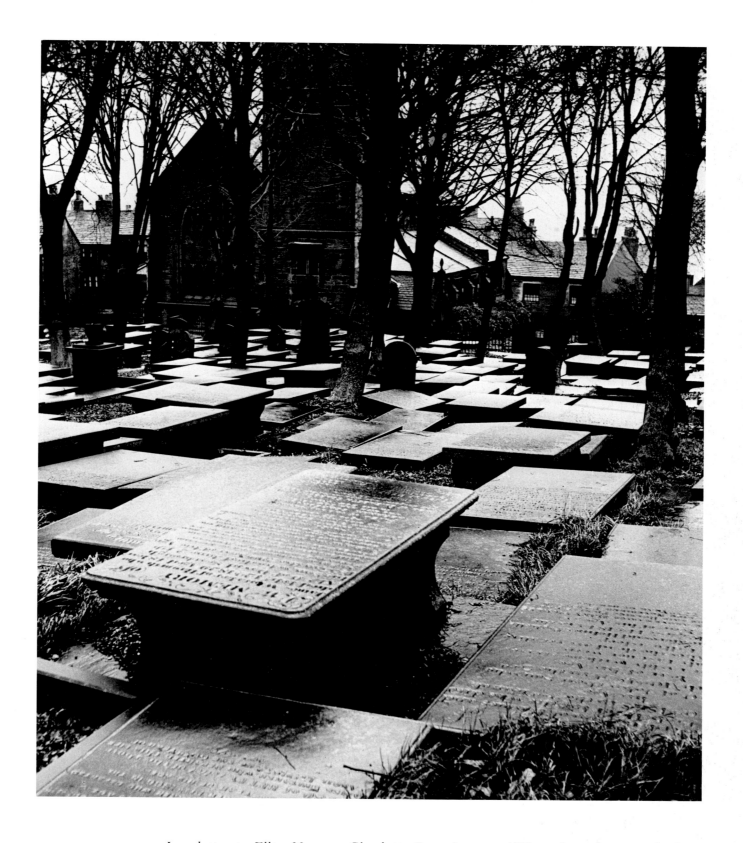

In a letter to Ellen Nussey, Charlotte Brontë wrote: "There have I sat on the low bedstead, my mind fixed on the window through which appeared no other landscape than a monotonous stretch of moorland, a grey church-tower rising from the centre of a church-yard so filled with graves that the rank weeds and coarse grass scarce had room to shoot up between the monuments." "The Brontës," from *Literary Britain*

59 Haworth Churchyard; after the Brontës

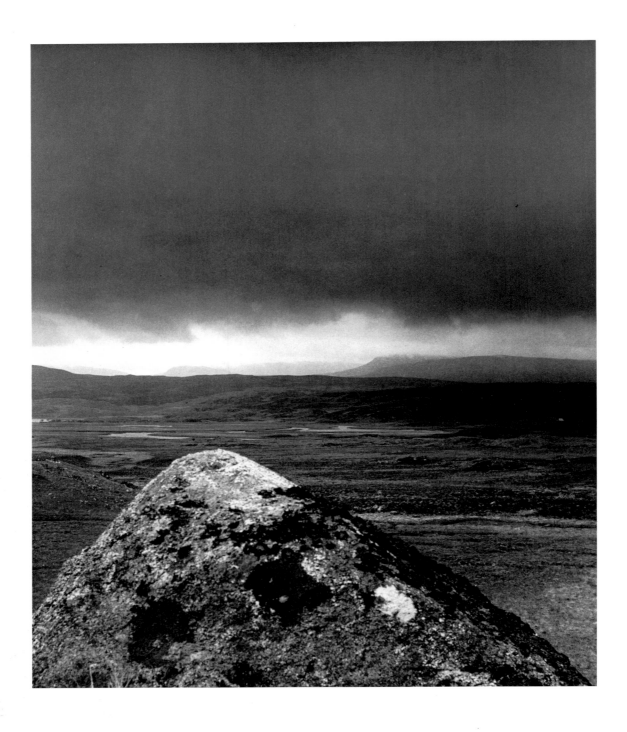

The mist rose and dies away, and showed us that country lying as waste as the sea; only the moorfowl and the peewees crying upon it, and far over to the east a herd of deer, moving like dots. Much of it was red with heather; much of the rest broken up with bogs and hags and peaty pools; some had been burnt black in a heath fire; and in another place there are quite a forest of dead firs, standing like skeletons. A wearier-looking desert man never saw . . . ROBERT LOUIS STEVENSON, *Kidnapped*, from *Literary Britain*

The band of silver paleness along the east horizon made even the distant parts of the Great Plain appear dark and near; and the whole enormous landscape bore that impress of reserve, taciturnity and hesitation which is usual just before day. The eastward pillars and their architraves stood up blackly against the light, and the great flame-shaped Sun-stone beyond them. THOMAS HARDY, *Tess of the D'Urbervilles*, from *Literary Britain*

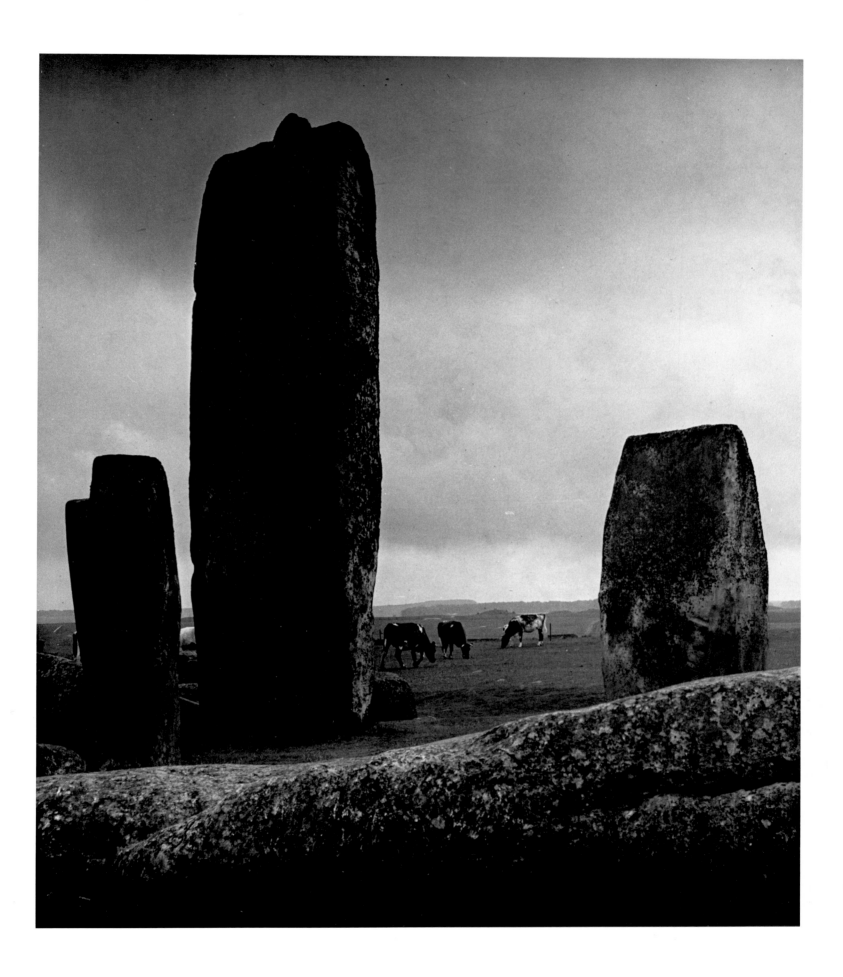

61 Stonehenge; after Thomas Hardy

PERSPECTIVE OF NUDES

The ninety photographs that make up *Perspective of Nudes* were the result of a pictorial exploration that Bill Brandt pursued for fifteen years, from 1945 to 1960. Rolf Brandt's fascinating collection of his brother's early, experimental photographs include a solarized nude study inscribed "Wien-London" and dated 1934. In February 1942, *Lilliput* printed Brandt's first published nude, a study photographed through muslin in the style of Erwin Blumenfeld. Two years later, after peace was declared in 1945, Brandt began this project and pursued it in earnest. On the advice of the painter and fellow-photographer Peter Rose-Pulham, Brandt acquired a brass and mahogany stand camera. His thoughts about this are reflected in Chapman Mortimer's introduction to *Perspective of Nudes*. Mortimer, who appears in some scenes in *A Night in London*, was a well-known novelist and long-time friend of Brandt's. In his 1961 introduction, he wrote:

> According to Brandt, modern cameras are designed to imitate human vision and perspective, and he says that having used them to photograph London in the thirties and during the war he began to find them too perfect. They reproduced life like a mirror, and their efficiency prevented him from entering the mirror. . . . He wanted a camera (as he thinks now because that was what he found) that would give him "an altered perspective and a less conventional image." He hoped for a lens that might see more: that might see, "perhaps, like a mouse, a fish or a fly."

The camera did not allow Brandt to see like a fly, Mortimer added, but "he could look into his camera as the storyteller once looked into his memory." The threshold of his new vision was nearer to the threshold of his imagination. Brandt intended to achieve all this with a camera which had been designed for use by untrained policemen. Although it has often been referred to as a nineteenth-century camera, this was the Kodak Wide Angle camera introduced by Kodak in 1931. It was in use by the New York Police Department and others during the 30's, and it required no skill to operate. The camera had a fixed lens which covered a 110° angle. Anything four feet or more from the camera was in focus. A frame at the front guided the operator. Any point in the room which could be seen inside this frame would be included in the picture. Brandt enthusiastically acknowledged a debt to Orson Welles's *Citizen Kane* (1941) and its wide-angle, deep-focus camera work.

Perspective of Nudes is divided into six sections. It begins with nudes placed in shadowed interiors, usually of the stately proportions of apartments in Campden Hill, Belgravia and St. John's Wood. As with the landscapes of the same period, the associations in these photographs are at once Victorian and modern. Furnishings and pictures establish a nineteenth-century atmosphere but the perspective from which the nudes are observed is post-Picasso. In the second section of the book, smaller rooms are shown—sometimes with glimpses of abstract paintings, Picasso prints and emblems of the seashore. The series evolves from twilit, romantic images in which the large Victorian rooms seem to impose on the figure to images of a more intimate scale and modern idiom. The distance between camera and model contracts further in the third section or "chapter." The body fills the frame. Then, in the fourth group, the nude is found under full natural light on the seashore. The fifth section returns

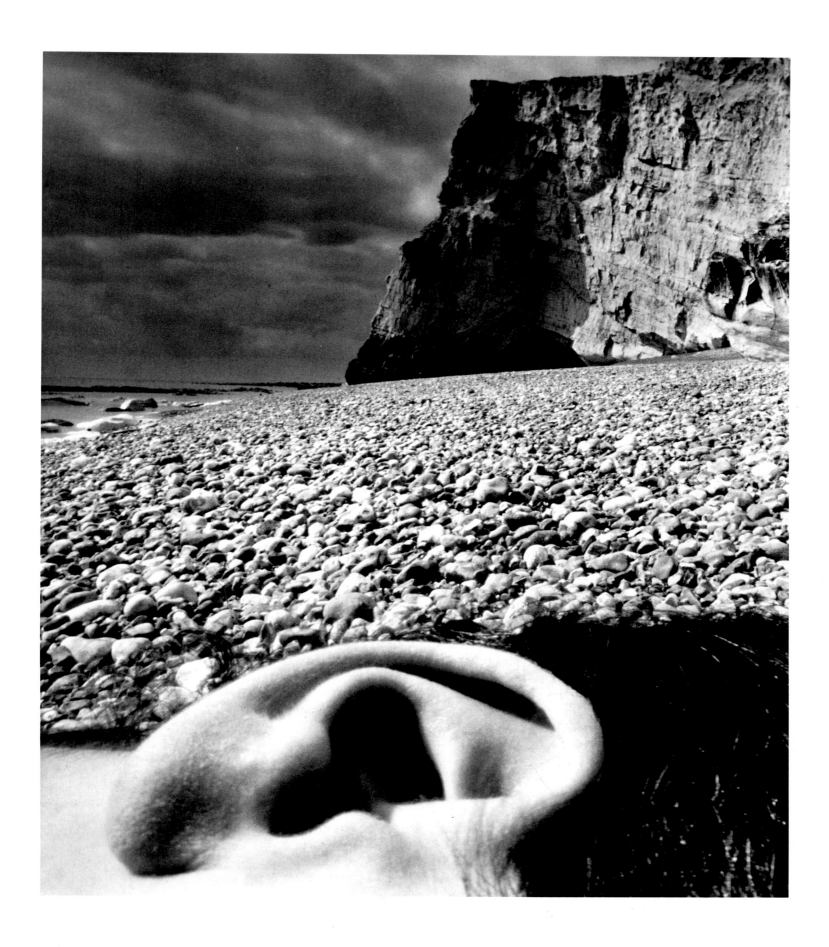

63 East Sussex Coast, 1957

to an interior. This room is a studio which contains mechanical instruments of unknown use and jaggedly patterned paintings. Having noted these contrasts in relation to the figure, the camera again moves close to the intimate parts of the body. The final section continues this erotic nearness on the seashore and, from plate to plate, detail by detail, it unifies the contours and weight of limbs with the smooth antiquity of marine objets trouvés and stone.

The series was photographed in years in which Brandt made his second marriage to the beautiful Marjorie Beckett with whom he had worked on *Picture Post*. They lived happily in London, and in a newly acquired apartment at Vence above the Baie des Anges in the South of France. (She died in 1971 and Bill Brandt continued to divide his time between London and Vence with his third wife—his widow—Noya Brandt, whom he married in 1972.) Marjorie Beckett was the author of the strange and perfectly apt title of the book that brought Brandt's whole achievement vividly to the attention of a new generation. *Shadow of Light* was published in 1966 with an introduction by Cyril Connolly, who likened it to the "collected works" of a poet. From then on Bill Brandt's photographs inhabited a large public domain, reaching into the imaginations of a public beyond any sectional interest of subject matter, medium or style. His work has passed into other minds and formed new kinds of imagery. One example that could be chosen from many is an extraordinary and enigmatic painting called *Screenplay* (1966). It is by the American painter R.B. Kitaj, who has chosen to work in London. *Screenplay* is based on two Brandt photographs which are superimposed and altered in Kitaj's painting. The first is the famous view of Top Withens, or "Wuthering Heights," with the derelict cottage perched on the moors. The second is a photograph Brandt took from inside Withens; a window frames a view in which the moors look strangely like a beach; and *become* a beach in Kitaj's painting. Several lightly painted concentric rings focus, like a range-finder, on the empty skyline, as if looking for a figure. The central image, seen as if through a window, is framed by a decorative device which is loosely reminiscent of Viennese styles of about 1900. However, as yet there is no sign of any dramatic event or concealed figure that would justify the title *Screenplay*. Looking closer at an ambiguous area of paint— which is applied in a manner analogical to the grain of newspaper photographs— certain forms between the beach and the moors seem to resolve themselves into the configuration of a nude. But if it is a figure, it is also simultaneously figure and ground. These forms belong in the language of heroic modernism and in particular to their adaptation by Bill Brandt in his book *Perspective of Nudes*. The forms in the painting are ambiguous and conjectural as they are in Brandt's work. The title *Screenplay* invites us to "read" the painting.

In *Perspective of Nudes*, Brandt tells a story. It is the tale of a journey from a shadowed nineteenth-century romantic past, through many changes of location and position, to a final destination—a sun-filled place of creative freedom and amplitude where everything seen has two simultaneous meanings. Perhaps, on the basis of what we now know of him, Bill Brandt was telling a story analogical to his own. During his life, he journeyed from a city in northern Europe where he grew up under constriction, passed through places during strange and surprising moments in their history, and finally reached the imaginative openness and sun and warmth of a Mediterranean shore. His creative imagination may have found a mainspring or dynamic in the contrasting northern and southern qualities in himself, just as, in Pierre Mac-Orlan's words apropos Atget, "le révélateur de la lumière est l'ombre." Light is revealed by shadow. The two opposites are astonishingly combined, as in the words "Shadow of Light" and the photographs they evoke.

MARK HAWORTH-BOOTH

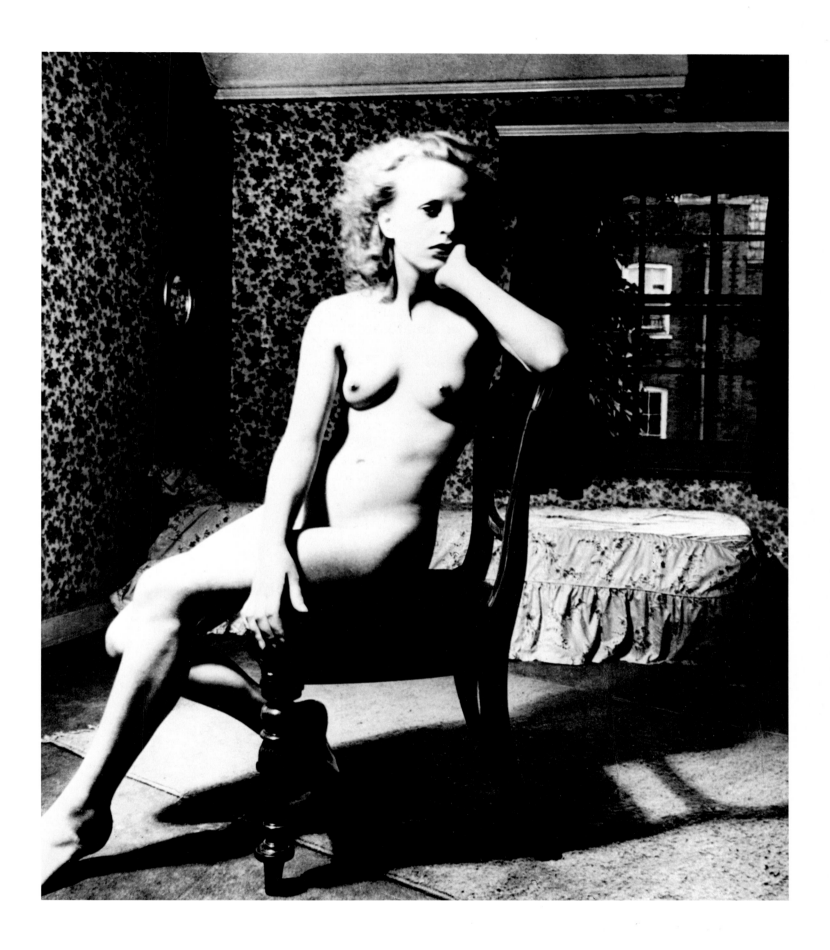

65 Hampstead, London, 1945

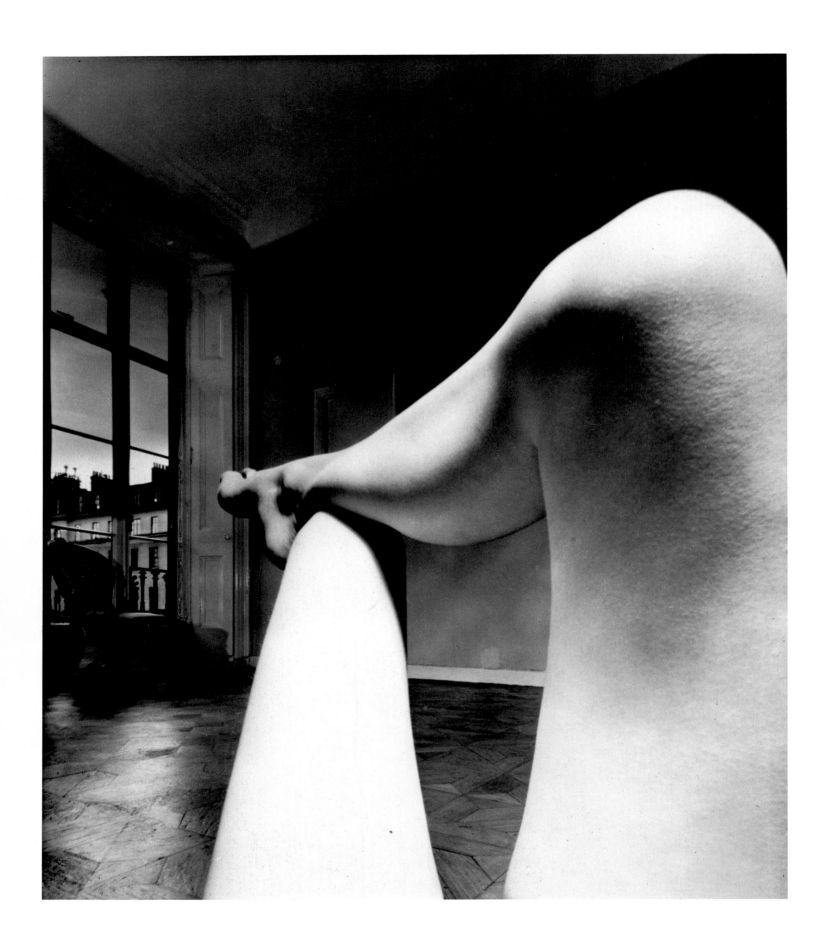

66 PERSPECTIVE OF NUDES Belgravia, London 1951

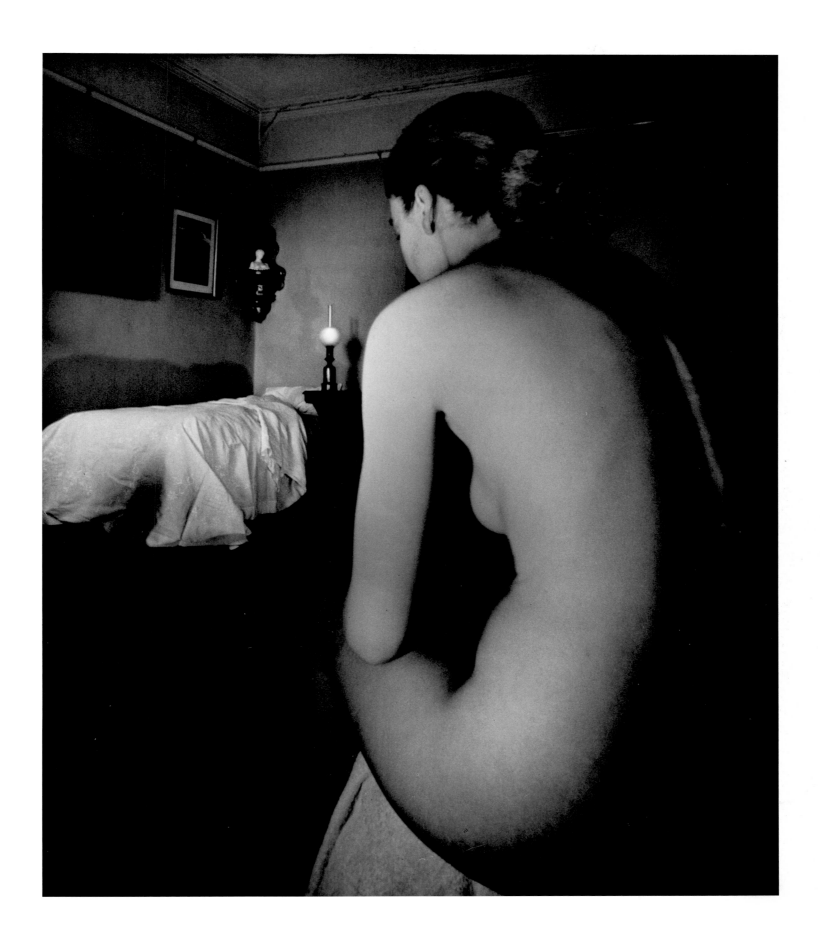

67 Campden Hill, London, 1949

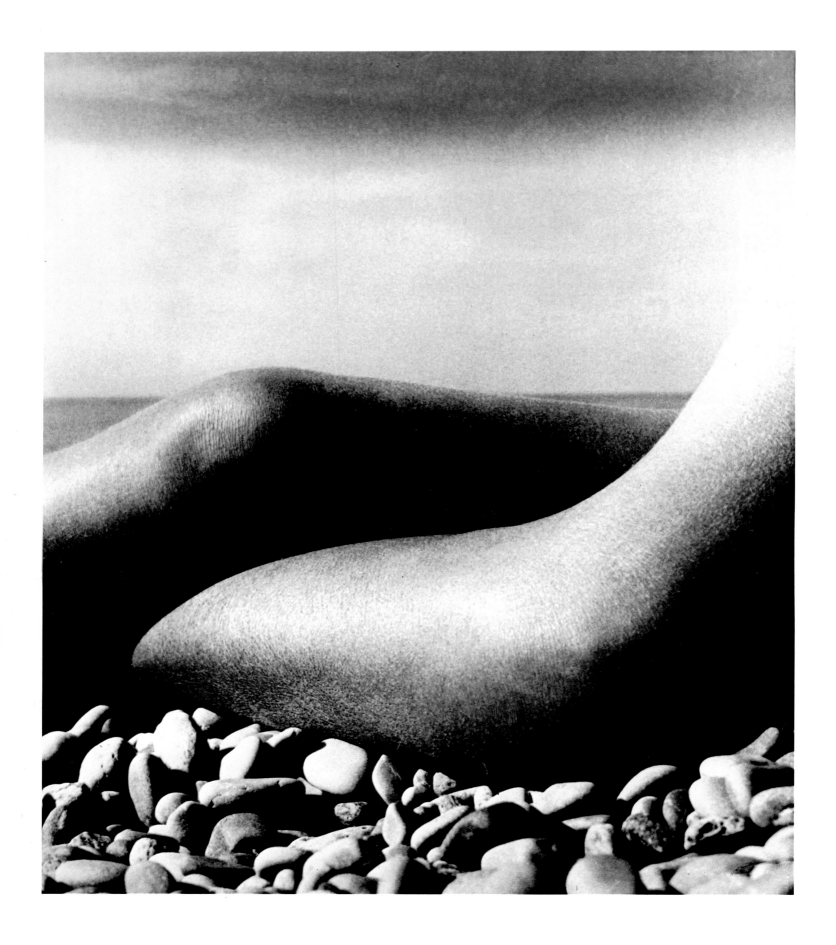

68 PERSPECTIVE OF NUDES Baie des Anges, France, 1959

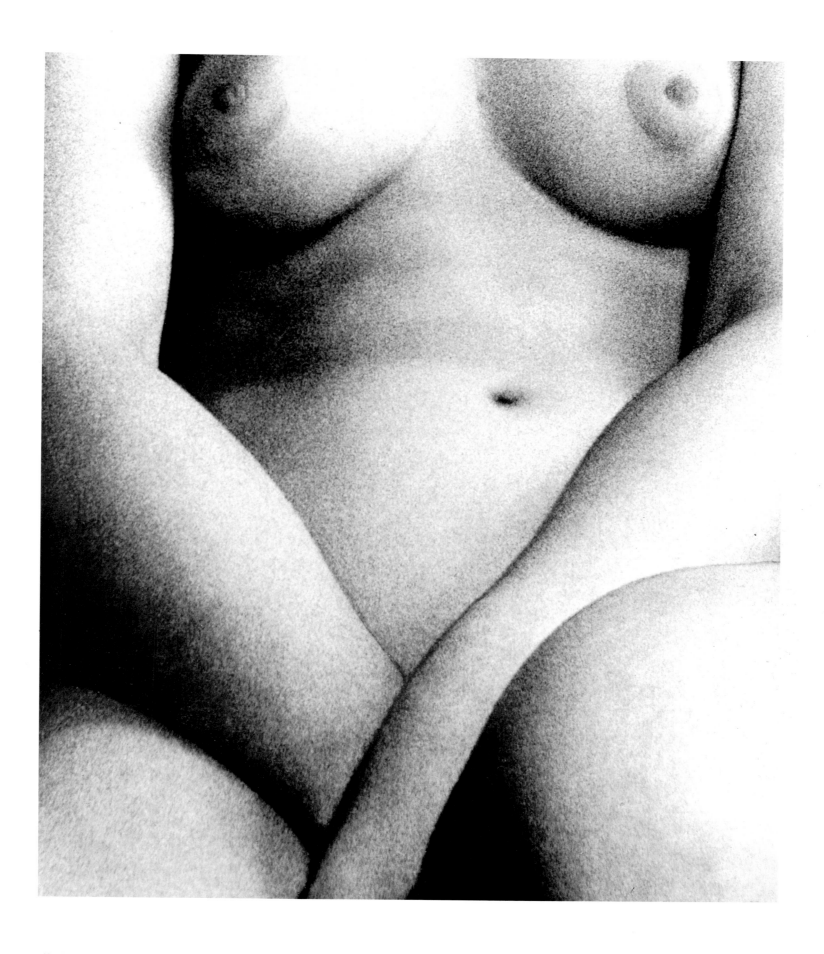

69 London, 1954

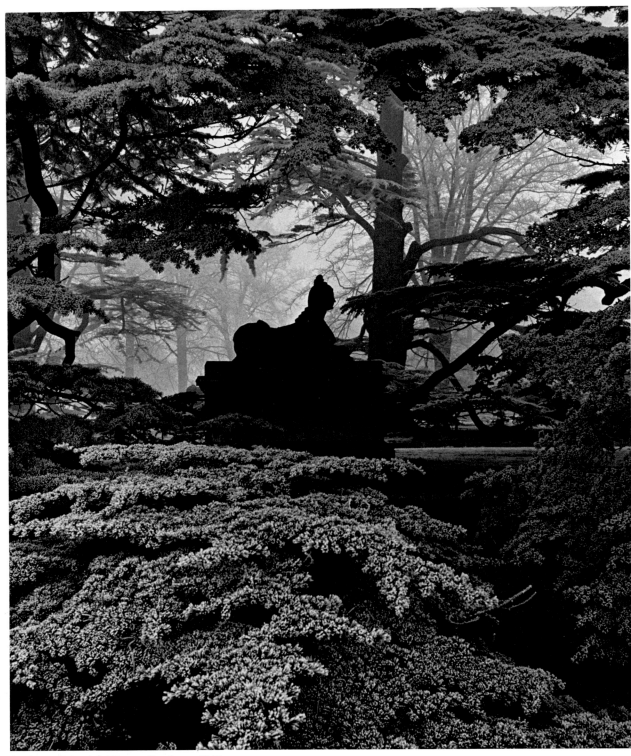

Sphinx, Chiswick House Gardens, 1944

BRANDT'S PHANTASMS

Obscurely and uncannily, all across his photographs, all across their formats and functions, Bill Brandt wrote a fragmentary and fantastic text. It is composed of emptinesses, statues, secret chambers, and children's books. The phantasms from that text are to be found far beyond most received accounts of him; beyond the compartments of genre and style, in another place, where the imperatives of desire, dream, and phantasy disclose far grander, if darker, schemes. And it is from there, on that ground, that these notes arise, among the fragments of his meditations on light, homeland, the past, and the erotic body. Where previous critical and historical gazes have fixed upon an evolutionary Brandt and seen him working in a set of genres—social documentary, landscape, portrait, nude—we shall represent him otherwise. Cutting across these categories are altogether other concerns, this other text. We shall trace Brandt's other discourses—illumination, depth-of-field, and framing—and mark them in relation to his representation of the body; his fascination with seeing, distance, and intimacy; his objects of desire and their substitutes; his phantasms—subjects such as Alice, Pratt, and the Daughter of the Policeman. And there, complicit with these figures, we shall find his grand phantasy laid out, as a map, a land, and a body—his photographic fiction of "Britain"—a Britain dreamed and somberly constructed in parental chambers. For we shall sketch Brandt's grand phantasm itself: Britain, his shadowed object of desire.

I. A RHETORIC OF BLACK AND WHITE

To Man Ray and his utopian inauguration of "The Age of Light,"[1] Brandt's antinomian rejoinder was an age of darkness: a darkness that begins in the black midnight shadows of midsummer noons with silhouetted Tic–tac men at Ascot[2] in 1933, and with the very prototype of his beach nudes in 1934, tanned to an aboriginal black.[3] When Tom Hopkinson, who was to be the editor of *Picture Post* magazine, first met him in 1936, Brandt was intensely tanned. Eight years after leaving behind the sanatorium light that had first darkened his fair skin, he was still in the habit of being fashionably "bronzé." Inscribed upon his face and body was the brand of bright, curative daylight.

That visual paradigm, for which Brandt is known, of a deeply shadowed face in bright sunshine comes first in German posters designed by Bernhard and Hohlwein in the first two decades of the 20th century. In the great blocks of those posters, black becomes a color; and at the end of his career, in the second edition of *Shadow of Light* (1977), Brandt recast and remade his photographs through intense printing as if in emulation of these schematic blacks. It was the gravure charcoal tableau that originally attracted reviewers to his picture book *A Night in London* in 1938 (". . . his photographs with their heavy shadows").[4] He moved along this register of darkness until the end of his life, encouraged by Steichen's

complaint in 1955 that the four prints Brandt had provided for the *Family of Man* exhibition were "too gray."[5] The darkness that begins to fall across Brandt's prints in the late 50's falls as hard printing. Brandt may well have had as his formal point of departure those polarized, abstract black-and-white contrasts that were disclosed in post-Nazi German vanguard photography. It was this small world of high contrasts that Brandt discovered when he purchased a copy of Otto Steinert's *Subjektive Fotografie* (Bonn, 1952). It was intensified

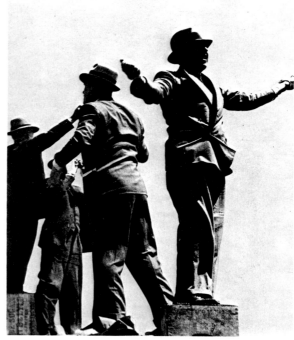

Tic-tac men at Ascot

too, by Brandt's earlier reckoning that somber images like his portrait of E. M. Forster (1947) were Symbolist keys to a Victorian past. ("I was forcibly impressed by the Victorian character of the room in which he sat. A hand print brought out this impression . . . adding its reminiscent effect to the Victorian setting.")[6] It was in the 1940's that his shadows began to signify the historical past: attentive to the texts and turnings of British history, Brandt chose to represent a sinister, macabre aspect of architecture. The black prison houses of British history and literature—Wormwood Scrubs,[7] the Tower of London,[8] and Berkeley Castle[9]—rise like the silhouette of Xanadu, itself a pastiche of earlier horror films, from a film Brandt accorded talismanic significance, *Citizen Kane* (1941).

The Shadowy Text. If, in his rhetoric of darkness, Orson Welles' film was important, so too was Michel Butor's novel *L'Emploi du Temps* (Passing Time) (1957). At the end of the 1950's, Brandt discovered in this novel similarities with his

own earlier experiences in the industrial cities of the North of England. Butor's novel presents a young Frenchman, a clerk, Jacques Revel, who lives in Belston, an imaginary city (probably based on Liverpool), an utterly alien town where blackness is the constituent element of the buildings, canals, beer, tea—even the inhabitants. Revel's first extended human contact in Belston is with a Negro—a man as black as the miners and coal gatherers Brandt had photographed (and

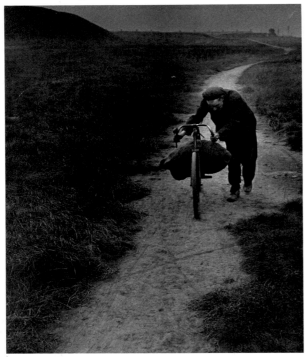

Coal gatherer
". . . leaning over his bicycle"

which he inspired Robert Frank to photograph in 1951). The black man is "huddled like a lump of earth under a coat, his body bent forward."[10] Revel's meeting with the Negro in a universe of urban and industrial gloom was reminiscent of Brandt's encounter with a miner: ". . . leaning over his bicycle; the man's clothes were black and the grass by the side of the path was black, as it is near pitheads. The scene was dreary in the extreme, yet moving by its very atmosphere of drabness. A dark print of the photograph added to the effect of darkness associated with the miner's life."[11] Butor's inhabitants of Belston, imaginary post-Victorian industrial peasantry, are bodies with coal superimposed upon them. Brandt was so impressed by the novel, figuring northern England as an interminable, hallucinatory 19th-century labyrinth, that he requested Butor to write the introduction to his great collection of the 1960's, *Shadow of Light*, when it was published in France in 1966. The French edition appeared as *Ombres d'un Ile* (Shadows of an Island). Butor's introduction took specific photographs by Brandt and transformed them, textualized them, as *nouveau roman*, alien fragments. Britain itself is represented as a black country, a Stygian island of the past—"*Une île plus nocturne que toutes les îles*" (A more nocturnal island than all islands).[12]

This Brandtian nocturne obscured and represented sites of

fundamental strangeness, where the subject or spectator was placed at a distance, like Revel. Brandt's early reading of Kafka's novels during the 1920's had sedimented in his imagination the iconography of interminable, dark environments and uncanny, melancholy urban patterns. One way in which he forwarded this iconography was in his photo-essays of weather effects in London in the 1940's, which appeared in *Picture Post* and *Lilliput*, two celebrated British magazines. Here was the spectacle of an endless metropolis of pilgrimage and mystery, emptied and made remote by fog, smog, and snow—denuded of commonplace significance. Brandt took the cloudy and oppressive theme of his photo-essay "The Day That Never Broke"[13] from the opening of Kafka's *Das Schloss* (The Castle) (1926), where images of obscurity muffle a figure arriving in darkness. "The village was deep in snow. The Castle hill was hidden, veiled in mist and darkness. . . . K stood for a long time gazing into the illusory emptiness before him."[14] The commercial context of "The Day That Never Broke" was the novelty photo essay which was standard in mass-circulation picture magazines of the 1940's; but Brandt operated against that context. By transcendentalizing, mythifying, and textualizing, he worked back in his career in the

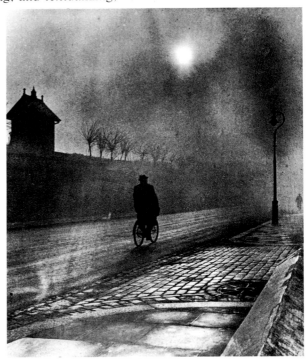

From "The Day That Never Broke,"
Picture Post, January 18, 1947

30's and 40's to the imperatives and iconography of Modernist literature, poetry, painting, and film.

Thus "The Day That Never Broke" shows a great London fog; in the four large, page–size pictures, we see a graveyard, an empty street with a lone cyclist, Berkeley Square, and the Thames at Chelsea. They are all parts of a shadowy London. Brandt very likely also freelanced the accompanying story in the form of lengthy four-part captions. It was a grotesque fable of a man who always wanted to be alone and who wakes to discover a catastrophic transformation; elements in the story

were strongly autobiographical. "For today he was alone in London. Abolished, by one gigantic smear of God's fog pencil, were the beastly faces of his 8 million fellow citizens." He journeys across London, through the obscuring fog that possessed "the whole purged city," before committing suicide. "Fog is the misanthrope's medium. . . ."[15] With snowfalls too, Brandt disclosed a negative metropolis of eerie urban villages and parks in a dialectic of black and white overseen by the Chiswick Sphinx.[16]

Film Melodrama and the British Vista. But it was only in the cinema that he could find satisfactory models for his own dialectic of black and white. In 1941–42 he was commissioned by Tom Hopkinson to make stills on the sets of several British films that were in production.[17] His experience of working under systems of illumination that were not his own but those of lighting cameramen seems to have decisively shifted his photographic practice toward tungsten lighting, arranged on cinematographic lines. His placement of figures within a frame also appears to have been displaced by working with dramatic, filmic methods of composition. By a point around 1942–43, his commissioned work for *Picture Post* and *Lilliput* magazines, including the most routine photographs of planning committees or weather forecasters, takes on the narrative characteristics of frame enlargements from detective and mystery films, alluding to "the aura of suspense" and melodrama. This complemented his well-established cinephilia: his repeated viewings of Luis Buñuel's early Surrealist films, Alfred Hitchcock's 30's thrillers, and Welles' *Citizen Kane* and *The Magnificent Ambersons.* Allusions to these films certainly spilled over into Brandt's photography. But also, the very experience of being in a theater—another darkroom, like the one he was consigned to by his mentor Man Ray— structured many of Brandt's photographs. In his book *Literary Britain* (1951), for example, there is a repeated re-creation of the filmgoer's experience of the screen. The images are barred off by masks of horizontal and vertical black bands. Scenes are set on dark thresholds or under black clouds, like the black mattes he later advised purchasers to place around his prints.[18] He adopted this tactic in the photo-essay "Brontë Country" in 1945.[19] He alluded to the rectangular cinema screen by going from inside the dark, derelict Top Withens—from *Wuthering Heights*—through the rough stone work window on to the moors white with snow.

There were many moments of recognition and identification for Brandt in the cinema. Carol Reed's trilogy of the late 40's— *Odd Man Out* (1947), *The Fallen Idol* (1948), and *The Third Man* (1949)—especially intrigued him. In the *The Third Man*, phantoms *do* stand in doorways, just as Tom Hopkinson had written of Brandt's pictures as early as 1942.[20] (Brandt was sometimes asked whether *Odd Man Out* might not have been shot by a pupil of his.) *Odd Man Out*, Brandt believed, was an example of "dark cinematography."[21] That film and *The Third Man* were dreamlike acts of mourning, prolonged wintery nocturnes of doomed, black-overcoated victim-heroes, all under the arrangement of Reed's exceptional lighting cameraman, Bob Krasker. Perhaps Krasker shaped, as much as Brandt did, the bleak visual imagination of postwar Britain in black and white. Even the last era of monochrome in British

cinema—moving now to the late 50's and early 60's—must be accounted for in relation to Brandt's oeuvre: forlorn northern vistas (Tony Richardson's *A Taste of Honey* in 1961); class ceremonials under servants' eyes (Joseph Losey's *The Servant* in 1963); and deep-focused, wide-angled, erotic hallucination in Victorian rooms (Roman Polanski's *Repulsion* in 1965).

Brandt had presaged all these cinematic gazes in the 30's and 40's. Now, in the 60's, film directors turned back to Brandt's photographs to instruct their percepts of Britain. John Schlesinger, director of *A Kind of Loving* (1962) and *Billy Liar* (1963), would later recount to Brandt how he had used

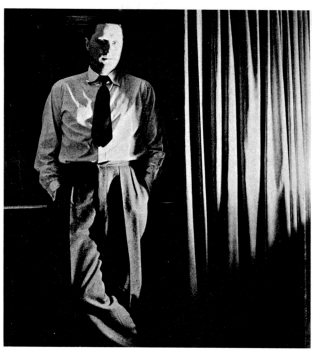

Carol Reed, *Lilliput*, February 1949

his published photographs by showing them to his actors as a preparation before shooting. But it was Lindsay Anderson in his films of the early and mid-60's, especially *This Sporting Life* (1963) and *The White Bus* (1966), who came closest to Brandt's version of Britain. *The White Bus* gathered a collection of strange North Country types and paraded them before a gloomy northern cityscape. Anderson represented costumed urban picturesque types, like those Brandt had forwarded in *The English at Home* (1936): a lord mayor, clerks, weird passengers going under the impassive eyes of a young girl (as in Brandt's great source book *Cherry Stones*). Brandt viewed an eccentric, monochrome Britain as an endless procession of *types*.

The *Umwelt* Domesticated. So dark are all these films (as if a tense midwinter was then a permanent state in British culture) that twilight is always upon the viewer. Brandt either chose twilight as the moment to make many of his portraits, or often he rendered the print to a twilight light. For example, he photographed "Policeman in a Dockland Alley, Bermondsey"[22] in daylight and printed it as a nocturne: day-for-night. In Brandt's overall text there is a long manipulation

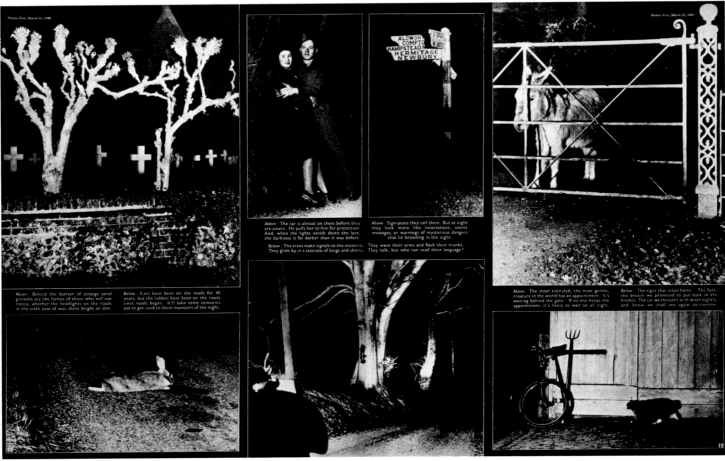

From "The Magic Lantern of a Car's Headlights," *Picture Post*, March 31, 1945

of the signifiers of darkness; one exemplar is his photo-essay for *Picture Post*, "The Magic Lantern of a Car's Head-lights,"[23] commissioned at the beginning of 1945. Once more that ghostly monochrome *Umwelt* was revealed through the agency of oneiric light—not occluding fog in this case—as the beams of car headlamps are released from their blackout pro-hibition. Brandt's repertory of the uncanny is also mobilized: the intruding gaze upon lovers;[24] the phantom on the street (a hitchhiking soldier); and that classic locus of the *Umwelt*, the graveyard. It was as if, in 1945, this photo-essay stood between the urban nocturnes of his photo-book of 1938, *A Night in London*, and the private night dreams of the late 40's nudes. "The Magic Lantern . . ." carried forward the Brand-tian theme of night's secrets and of darkness made visible, a theme in which were deeply embedded certain metaphors about photography itself. Like his snowfall pictures, "The Magic Lantern . . ." shows a paradoxical, negative world in positive prints, all laid out on the pages of *Picture Post* with a black background and reversed-out, white-on-black cap-tions. The world of night is suddenly revealed as if in the light of a flashbulb's discharge.[25] Where "Flaubertian detail"[26] had been Brandt's aim in his sharply focused photographs of 30's dinner tables in upper-middle-class and working-class homes, that naturalistic revelation had lapsed by the 40's.

The Irradiated Scene. Naturalism of a kind was still at its apogee in *A Night in London*, where the central structure

may be thought of as light itself. So felt James Bone, the author of the book's introduction, itemizing the way in which a *fas-cinating* light seemed to configure all the plates in the book. Brandt himself referred later to the fascinating "glitter"[27] that winks and stares back at the spectator.[28] "It is the glittering night of London that the camera of Bill Brandt sees. Floodlit attics and towers, oiled roadways shining like enamel under the street lights and headlights, the bright lacquer and shining metals of motor cars, illuminated signs, the reflections of strong lamps on the river, searchlights, the bright dog-racing arena."[29] Reflections also serve as light sources; and some-times, as in Brandt's plate of motor traffic at Piccadilly Circus, the glittering object is redoubled in the frame: the glistening traffic is echoed in an advertisement that shows the shape of a car in neon outlines.[30] The fascinating materiality of the world is brightly asserted, *repoussoir* from black depths through the sooty gravure surface of *A Night in London*.

An early sign that Brandt's light also dematerializes, and signifies a noumenal (and later Manichean) world, is present in an unpublished portrait of his first wife, Eva Boros, made in Paris in 1931–32. Her upper body is evanescent, transfigured by an effulgence of light from below (a prefiguration of Brandt's 1966 self-portrait); her face is so tanned that her blonde hair appears dark by contrast. In this portrait of ir-radiation there is a particular pathos; physical being—like the absurdist hero of "The Day That Never Broke"—seems to

be on the point of dissolution. Here is, perhaps, a metaphor, one that arises during his (and Eva's and his second wife, Marjorie Beckett's) prolonged treatment for tuberculosis in the 1920's. In Davos in the late 20's, as at other sanatoriums, Brandt sat on high, ranged balconies, exposing his body to the air, being devoured by light. Thus so many of his objects of desire, as he represents them photographically, are white phantasms of room and beach. After the strained melancholia of the confined, night-visiting nudes of the late 40's, there is a return to Continental sun and southern light (even in his British beach scenes our location is the south coast, facing

Eva Boros, Brandt's first wife,
Paris, 1931–32

France). The body is dislocated in his 50's nudes, recovering from 40's privations and sickness. Cyril Connolly outlined that scenario in his book *The Unquiet Grave* (1945): "The sole of the foot, the nape of the neck, still recollect the embrace of the Mediterranean. . . . In the breakup of religions and creeds there is but one deity whose worshippers have multiplied without a set-back. The sun. In a few years there will be a stampede towards this supreme anaesthetic. . . . Southern Englanders will have migrated en masse to the Mediterranean."[31] But this sunbathed, paganist, essentially *curative* theme, is only a moment in Brandt, only one of the fantastic significations in his articulation of light. From Man Ray's studio he cherished a photograph by the American of the great white hull of a racing yacht seen from below—a white flowing arabesque like the swelling anamorphic limbs of Brandt's beach nudes.

After exposing the body to light (through photography), after goggling the eyes from intense ultraviolet rays—what follows? The subdued room: first, the room of his psychoanalyst Stekel in Vienna; then, Man Ray's darkroom; and finally, coal-black England—its mines, tenements, and its East

End. Brandt also valued the plenitude of black, the silhouette, its gulfs, and its annihilating deep spaces. In his Manichean printing of the 60's and 70's, and in his high, late style, the contrast of black and white, the tensions of those forces, becomes paramount. In his portrait of Alain Robbe-Grillet (1965)[32] there is a single vertical strip of black, in which the floating cutoff head of the writer is pincered by the blind white door and the corner wall, his very body under threat of disappearance. Whiteness, in Brandt, came also to signify threat and loss. For there was one specific place, one location, where Brandt had received a lesson about such blank white spaces and their capability to generate sensations of displacement and lack. This was at the Haus Möller, built by architect Adolf Loos in Vienna in 1928.

Imaginary Rooms and Spaces. The cultural field in which Brandt came to maturity was that final flowering of Viennese art and letters in the 1920's, the culture of *finis Austriae*. Through the salon and informal school of Dr. Eugenie Schwarzwald in Vienna, Brandt had access to Karl Kraus and Adolf Loos, whom he met there around 1927. Brandt was fond of Loos, and from conversation became familiar with the broad lines of Loos' poetics of architecture and space. Loos' master concept, his guiding notion, was *Einfühlung* (empathy) between human subject and living space. Nearly thirty years before meeting Brandt, Loos had codified his theory of "*einen warmen, wohnlichen Raum*" (a warm and homely space).[33] His sketch of the sheltering atmospheric room, where the individual felt his psyche protected, was crucial for Brandt's development of his own poetics of space in his photography of the second half of the 40's, spanning out across his nudes and his portraits of that time. Brandt's turning inward to the private sphere from a public one, to a concept of the intimacy and special *Stimmung* (atmosphere) of the room, has a textual source in Loos. The search for a gratifying, atmospheric room is announced as a theme by Brandt in the 40's: ". . . there was never enough time for me to do what I wanted. My sitters were always in a hurry. Their rooms were rarely inspiring backgrounds and I felt I needed exciting backgrounds to make pictures of the portraits. I wanted more say in the portraits. I wanted rooms of my own choice. And so I came to nudes."[34] Dissatisfaction, thwarted wishes over the portraits, he writes, clustered around the image of the special, personal room. The metaphor of the atmospheric enclosed space at the Haus Möller offered Brandt the prototype of another kind of individual: empty, featureless, and uncanny.

The Haus Möller frontage was photographed by Brandt soon after its completion in 1928: a large blank facade giving onto a sloping street. With his brother Rolf, who was then studying at Vienna University, Brandt went carefully over the interior. He could not have helped being struck by the antithesis between Loos' earlier advocacy of intimate spaces and the environment of the Haus Möller. "The desire for emptiness is the most important feature of Loos' last phase of work. . . . The main factor in the composition of the facade is the cutting edge of the white, perfectly rectangular wall . . . the architecture of negation. We are faced here with the arrival of nihilism in the abstract."[35] Inside the negative, alien space

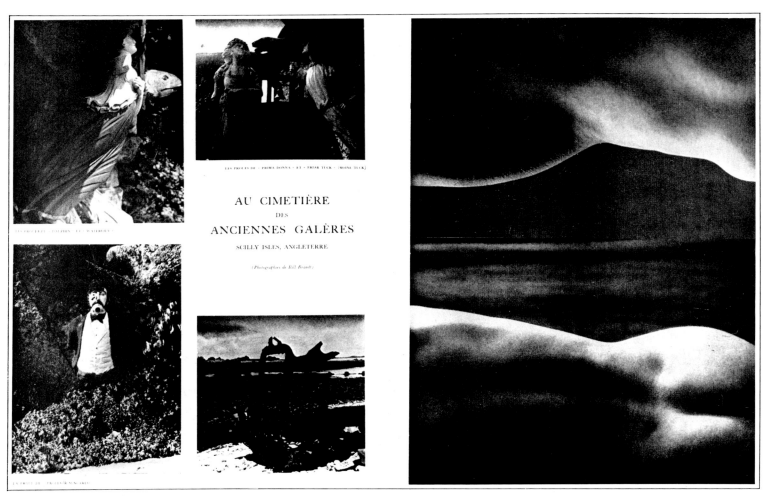

Brassaï's "Ciel Postiche" (1934) and Brandt's photographs
of ships' figureheads, *Minotaure* magazine, Winter, 1935

of the house, the occupant or visitor was put in the position of an intruder trying to regain intimacy in order to "occupy a foreign container."[36] Thus, a full year before he was to encounter Surrealist theory and the imaginary spaces of de Chirico's paintings, Brandt had been granted a vision of a displaced, altered, and disturbed space as a viewing subject.

Brandt repeated the flat schematic pattern of his photograph of the dumb facade of the Haus Möller again and again in his pictures of uncanny houses for *Literary Britain* through the 40's; he used it as well, at the end of the 30's, in his photographs of early 19th-century London house frontages. Such a photograph is "The Sun in Hampstead" (1938),[37] a terse, blinding picture with cold, bright spring sunshine falling upon a Regency house in front elevation, the facade cropped like an enlarged print, the white surface punctuated by two dark windows. Architecture as the pretext for denatured, geometrical pictures had been embedded in the mentality of Modernist photography with Paul Strand and Charles Sheeler's work of the late 1910's. Parallel to Brandt in Britain in the 30's was John Piper, who found elements of a Constructivist geometrical order in 19th-century functionalist seaside architecture such as lighthouses. Planar surfaces and deep

black windows punctuate Piper's photograph "Portland Bill Lighthouse," published a few months before Brandt photographed the Hampstead facade.[38] The biting light and contrasts of white and shadow in both Piper's and Brandt's photographs from 1938 also referred to another shared lineage: that specific 30's cultural fantasy of sunlit seaside order (shared too in Cyril Connolly's heliotropism, as we have seen earlier).

The Body as Landscape. Piper wrote that his photograph of the lighthouse emerged from just such a constellation of cultural structures, "a wave of enthusiasm for the possibilities of modern seascapes, and in the light of Constructivist painting and the beach-scapes of Picasso and Braque."[39] The white, bleached metamorphic bodies of Picasso's bathers of around 1930 and Braque's paintings of an overcast, pebbly Normandy had an immense impact on Brandt. He saw them in reproduction in the early 30's in Paris; he was still using them as models for his beach nudes in the 50's. Like the estranged white blank of the Haus Möller and the dismembered limbs of Picasso's bathers, another image became sedimented in Brandt's visual imagination: Brassaï's metamorphic photograph of a nude, "Ciel Postiche" (1934). Brassaï's picture doubled (inverted) a woman's horizontal body to form a great

cliff or landscape. It was reproduced in the Surrealist magazine *Minotaure* in 1935,[40] opposite Brandt's photographs of ships' figureheads in a garden in the Scilly Isles.[41] Here were two displaced versions of the body—Brandt's fetishistic dummies and Brassaï's nude as landscape—facing each other as a spread. Brandt would reclaim Brassaï's cryptomorph[42] and rework it as a solarized nude.[43] Then, more than a decade later, he translated it back into the British landscape—Brandt's object of desire in the 40's.[44]

Legible Bodies. Brandt's desire turns upon the construction and representation of the female body: whether lost in landscape and beachscape, waxing in Surrealist mutation and exchange; seen intimate and close within its empathic room; alienated in an uncanny room; or displaced by a statue or dummy, altered and framed. To these ends he was a great simplifier. Turning over the pages of *The English at Home* (1936) or *A Night in London* is like leafing through a primer or alphabet book—each photograph stands like a letter, a simple black graphic sign on the page. Brandt attended to ways of representing the body as a flat hieroglyph, like the schematic lovers in "Top Floor"[45] or the equally flat-planed Tic–tac men in "Bookmakers' Signals."[46] As we shall see, Brandt invested heavily in the metaphor of the elementary children's picture book.

Writing appears not just as the English and French captions in *The English at Home* and *A Night in London*, not yet in his own exact descriptions for *Lilliput*, but flourishing within the frame itself. *The English at Home* has such pictures, juxtaposing human figures and texts, or rather condensing body and text. "An Epsom Bookmaker," as the caption reads, is announced again, within the photograph, as "Sailor Cox."[47] A multitude of drawn, chalked, painted, and printed inscrip-

tions surround the living body of Sailor Cox—a white silhouette in the middle of a cubist assemblage of modes of writing. Brandt found similar "legible bodies"— persons as self-advertising texts—at those spectacular, placarded occasions and sites in British public life. In Hyde Park, for example, he photographed a salvationist disappearing behind his collaged frontage which announced in white-on-black lettering: CHRISTIAN.[48] At the Derby at Epsom, he photographed the black tipster, Prince Monolulu, in his African tribal costume: the legible body, on this occasion made explicit not by text but by Brandt's delineation of the fantastic headdress. This was Brandt's visual counterpart to Flaubert's strategy of minute detailing of clothing—as in the infant Charles Bovary's cap at the beginning of *Madame Bovary*, one of Brandt's favorite novels.[49] The elision of body and text finds another variant in Brandt's repeated representations of absorbed readers—literally the people of the book, as in his photograph

Still from Alfred Hitchcock's film *The Ring*, 1927

of rabbis and scholars reading Torah underground,[50] from his series documenting air-raid shelters for the Ministry of Information in 1940.[51] In the *Lilliput* photograph of a young woman asleep in a park with a book across her face, girl and text—body and text—are conjoined in the doubling caption "The Booksy Girl."[52]

Such doublings of figure with text required a uniform or absent background: the blank, to-be-written-in space of a poster, or the sky behind the Tic–tac men.[53] The allusion in this photograph (and for an adjacent image in *The English at Home*, "An Ascot Grandstand")[54] was to Brandt's memory of one of Ludwig Hohlwein's posters, a design for Rumpler Luftverkehr, showing two elevated male spectators in silhouette, observing a far-off sight. Brandt's brother Rolf re-

An Epsom Bookmaker

membered both him and Bill poring over this poster in reproduction—scanning these scanners—in the poster-art magazine *Das Plakat*[55] in 1920. Hohlwein's silhouetted posters were an important element in German graphic design in the 1910's and 20's. His posters of shadowy top-hatted and evening-dressed men, raffish denizens of metropolitan night life,[56] remained lodged in Brandt's visual imagination. They were mobilized, resurrected as toffs in *The English at Home*.[57]

For Brandt their context was clear: his photograph in *The English at Home* "After the Celebration"[58] was staged after

After the Celebration

those schematic black silhouetted types, those *Grossstadt* (metropolitan) revelers seen listlessly returning at dawn through the streets of Berlin at the beginning of the film by Ruttmann *Die Symphonie der Grosse Stadt Berlin* (The Symphony of A Great City) (1927). When Ezra Pound was introduced to Brandt in the summer of 1928, Pound had just seen Ruttmann's big-city *Querschnitt* (Cross-section) film, in Vienna and admired it. Pound was much taken up with the iconography of the metropolis at this point, writing an article that summer, "The City," where he dwelt upon the utopian city of the future with its conventional imperatives of "air, sun and freedom." But Pound also reckoned with the current semi-archaic metropolis: "The city of today is picturesque, and demoded, it belongs to the gothic phase of our cycle."[59] It was that very same metropolitan picturesque quality that engrossed Brandt. In the late 20's he began to fill small scrapbooks, his *Kleberbucher,* with glued-in photographs from magazines and advertisements of *Grossstadt* types—gangsters, capitalists, whores—all fantastic figures from urban life. Hemingway's laconic poems of a hard-boiled universe were also copied into the *Kleberbucher* by Brandt. He began to

figure ways to represent these transgressive images that he was to describe in 1951 as: ". . . the impression of seething and glittering life at night in the Metropolis."[60] Here was a fascinating, libidinous spectacle of figures of phantasy.

Brandt and the Silhouette. In the 1920's, one of the main agencies for such *Grossstadt* spectacles was the publicity poster, dominated by the silhouette. As in the magazine *Das Plakat*, film, dance, press, and food advertisements relied upon *die Aesthetik der Silhouettes*.[61] Silhouetting is probably the main spatial construct in *A Night in London*: configuring lovers, skylines, darts players, clothes, warehouses, and prostitutes' clients.[62] Brandt was staging his *Grossstadt* romance of a decade before projected upon London—its picturesque types, signs, and representations seen as urban silhouettes. Silhouetting came to the fore again as a figurative tactic in his "Blackout in London" photo-essay for *Lilliput* in 1939,[63] where he recycled three of his plates for *A Night in London* by suppressing any internal lights and darkening the prints.[64] That world could be reversed out; that is, there could be white silhouettes as well as black. Brandt's mid-30's photograph of a stork in Kew Gardens—a white specter taken at dusk[65]—returned him once more to German posters of the 1910's, especially those for the Berlin Zoological Gardens by Hohlwein and Klinger.[66] He returned to the tall, elegant arabesques of Jugendstil, the decorative style of his infancy in Germany. His abiding interest in this motif—the bird in profile or as an arabesque—led to his purchase in the 30's of a print by Audubon of a heron or stork, which he hung in his Hampstead flat.[67] It served as a displaced caricature of himself, wittily metamorphosed into a "found" version, in nature, of those Jugendstil or Art Nouveau languages that Dali and Surrealism began reviving in the early 1930's.[68] The attenuated bird on the walls of the Hillfield Court flat looked across to a framed reproduction of Dali's *La Persistance de la Mémoire* (The Persistence of Memory) (1930). Dali's long-curved, anamorphic figures would be appropriated as elements for the extruded universe of Brandt's nudes.

An Archaic Mold. Brandt's adolescent perception of the visual arts was schooled by graphic design in the afterglow of Jugendstil. This was a time when prestige was increasingly attached to graphic and poster design over fine art.[69] Before the turning points in his career, before Vienna and his encounter with psychoanalysis, and before Paris and his reorientation by Surrealist practice and theory, his initial context was within late Jugendstil strategies. He strongly identified with the draftsmen of the Munich commercial artists' group called "The Six"—among them Valenty Ziétara, Julius Gipkens, Pretorius, and Schwarzer—ingenious silhouettists in that period of his childhood and adolescence up into the early 1920's. The developments in Brandt's imagination from 1919 to 1929 need marking with great care; his early identification with the poster becomes transferred to something else. It was during this decade that the poster became more systematized and rationalized and was fully enrolled in the emergent technocratic order of the stabilized Germany of the second half of the 1920's. As it did so, Brandt transferred his investment in this form to another kind of picture making—photography—where he would nevertheless conserve the formats of the art

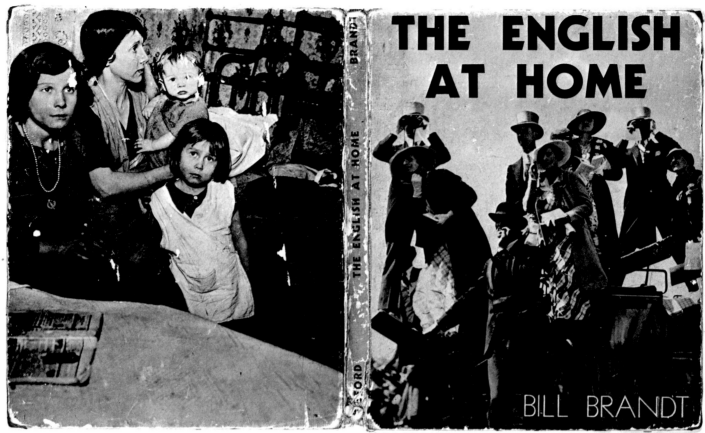

Front and back cover of *The English at Home*

poster as fixed in its pre-Modernist plenitude of 1910 to 1920: the moment of his love for it, the moment before the knowledge of Modernism. Brandt's poster- and illustration-derived photographs of the 1930's were archaistic, and like the schemata he retrieved from his childhood picture books, they recalled for him a certain phantasy of the past and infancy.

Cleaving to that, Brandt's photography is conspicuous in its refusal of that kind of Modernism that formed a pan-European movement with figures like Moholy-Nagy, Maurice Tabard, Man Ray, and Rodchenko at the close of the 1920's. Brandt entered photography during that moment when it too, like graphic design, was being transformed on the terrain of the New Vision and the new journalistic practices in Germany and in Paris. But Brandt refused to be the belated follower of Man Ray or Renger-Patsch, even while attending acutely to both their work.[70] His countervailing drive was away from formalist Modernism, disdaining asymmetry, high and low angles. (''I am not very interested,'' he wrote dryly, ''in extraordinary angles.'') He moved toward a kind of Neo-Pictorialist archaism: slabs of massed tones, auratic atmospheres, silhouettes, and centered single figures—tactics generated, perhaps, by carrying over structural principles from pre-Modernist poster designs into photography. Hence one finds that retarded, ominous aspect of a Neo-Pictorialism intact and triumphant in *The English at Home* and *A Night in London*. The influence is undeflected in the 40's, combining with new components—film lighting and deep-focus space—and still present in his manipulation of his earlier prints into the poster

blacknesses of the second edition of *Shadow of Light* (1977). When Tom Hopkinson came in 1961 to review *Perspective of Nudes* (1961) he was evidently troubled by the resemblances between Brandt and the Pictorialist photographers of 1900. That anxiety is manifest in his writing; the legitimacy of Pictorialism and Brandt's experiments of the 40's and 50's appeared to Hopkinson difficult to validate. During the ascendancy of the ''decisive moment'' in 1961 he wrote: ''It is possible that in the face of present fashion, this book will be misunderstood. Its rejection of the time element and its concentration upon space may cause some to confuse its assured abstractions with the banalities of the old time studio photographers.''[71] Hopkinson's criticism of ''the old time'' repressed precisely the willed, conscious reconstruction by Brandt of a pre-Great War lost infancy—of ''the old time'' and its systems of pictorial representation—all across his own photography.

II. HOMELAND

Between the ages of 10 and 14, this child of an English father and German mother was surrounded by hostility to Britain. Through the First World War, he was persecuted by German schoolmates because of his Englishness. In the magazines and journals that came into his home, images derided Britain. In the posters reproduced in *Das Plakat* each month, Union Jack flags were righteously torn down by virtuous Germans,[72] and top-hatted Londoners scattered under the black wings of the

German air fleet.[73] His father Louis' British nationality was a great focus of tension for Brandt: his place, position, and identity were under threat. In Britain his banking family was part of the patriciate; in a Germany at war they were aliens, persecuted pariahs. Out of this situation for the young Brandt grew a nostalgia for that entity "Britain," and a good, lost, pre-Great War childhood. "Britain" would be his true *Heimat* (homeland), a wish that was to be the determining factor in so much of his photography. We might speak here of Britain becoming his lost object of desire—to be watched, adored, figured, framed, and pictured. His phantasies of origin strove to deny, split off, and reject Germany, inverting the chauvinist phobias that crowded around him while pursuing that wish for union with a distant (and past) English at home.

The Homeland of the Uncanny. In 1919 Sigmund Freud published his study "Das Unheimliche" (The Uncanny), relating patients' anxieties, their estrangement and alienation, to a "nostalgia for lost intimacy."[74] This has extreme relevance to Brandt, to his optic, and to his system of representations. To begin with, the strange and the uncanny are key operational devices in Brandt's projection and construction of Britain. In the same year as Freud's essay, Brandt began to assemble his reparative vision of Britain, fed by the pages of *Das Plakat*. With that first year of peace, the contaminated representation of Britain formed by the intense chauvinism of Germany at war began to recede.[75] The first major British graphic artist to be given prominence in 1919 was Frank Brangwyn,[76] a late Romantic. His dark lithographed war posters were often reproduced, displaying a Britain of monumental heroes, patriarchs of home and hearth—the first ennobling image of Britain that the fourteen-year-old Brandt had seen for years, apart, of course, from his carefully tended English children's picture books. Could such pictures close the gap and return him to his "lost intimacy"? Yet Brangwyn's lithographs represented the English as melancholy figures lost in a somber, coallike blackness—miners, industrial workers, and soldiers filed across the posters as oneiric giants. Brandt's homeland seemed unearthly, a perception learned from images. He was to translate his perception back into his coding of many of the figures in *The English at Home*: the forlorn apparition of "A Billingsgate Porter," those paternal statues the Tic–tac men, and the "Miners Returning to Daylight."[77] Ostensibly the last picture is a documentary photograph—the "documentary" being the manifest category for the book itself—but Brandt made a point of clarifying its implicit significance. He said that he was representing the miners from an altogether other register, that of the *phantasmic*. He spoke of the integral *weirdness* of the miners in his photograph: ". . . they had black faces and their lips were very red and their eyes were white and strange. . . ."[78] *Das Unheimliche*, the uncanny, is inscribed in his construction of the English at home; estrangement is evident even at the moment of "coming home" to Britain in the early 1930's.

Estrangement: a repeated withdrawal and distance had become a way of living for Brandt in the previous decade. In the aftermath of the stress of war and unhappiness at school, he contracted tuberculosis in 1922. An epidemic of TB followed the Great War. Karl Kraus, the satirist whom Brandt

was to know and admire in Vienna, wrote (with deliberate exaggeration) in 1920: ". . . the mass of the Austrian and German people got rid of the Hapsburgs and Hohenzollerns only to die instead of tuberculosis."[79] At sixteen Brandt quit Germany for Switzerland, becoming, for more than ten years, one of those cultured internationals who came to rest in Central Europe. He was one of the *Heimatlosen* (country-less). Displaced Russians and Austro-Hungarians, exiled Americans like Pound and Hemingway, all made up this body of expatriates. Ezra Pound commented on the phenomenon of the *Heimatlosen* in 1921, singling out a common ideology ". . . that it is a calamity to belong to any *modern* nation whatsoever. I suppose the present phase of the discussion began with the *Heimatlosen* in Switzerland during the war."[80] Brandt's drastic disaffiliation from Germany and his wish to recover a "lost intimacy" through the body of Britain was predicated on his "old time" phantasy of Britain: that it still possessed a pre-Modern, Victorian or Edwardian, society and culture, as it had maintained—in the nostalgic mise-en-scène of his childhood—before the Great War.

Cities of the Text, Countries of the Text. Like Vienna, where he happily settled, London bore little trace of being the capital of any modern state. From Vienna, "London was a dream."[81] His phantasy of London—and of Paris—was a textual one; they were homelands of the book, cities constructed from literature, dreams fabricated by his extensive reading as child and adult. Paris was Hemingway's fiction; it was in the early parts of *Fiesta* (1927) ("Why don't you start living your life in Paris?").[82] London, and indeed Britain itself, was mapped in terms of fabled sites. Brandt's strategy of condensing body and writing was amplified by his construction of Britain as the "old time" land of the text. Thus *Literary Britain* unfolds a set of places to be imagined, primarily through reference to a textual authority, that validating bible, English literature. Surrealist taste itself had turned to place in its pantheon the writings of Shakespeare, the Brontës, and Lewis Carroll. Dali himself, in 1930, endorsed "le masochisme de Thomas Hardy."[83] Writing and reading consumed Brandt as much as the light and air on the sanatorium balcony at Davos. At this time (1926–27) he read Kafka, Dostoevsky, Flaubert, and de Maupassant. These writers, along with Hemingway, programmed his picture of Paris and France. For Brandt the country was constructed by text. Later in the 50's, he visited Italy and left after only a short stay. He had "failed to recognize it," since he hadn't read the literature of the country.[84] Dickens' novels mediated Victorian Britain for him; he first and always associated the scene of a small gypsy boy sitting by a tent at the Derby, which he photographed in June 1933, with the pathos of Dickens' waif-child heroes, especially David Copperfield.[85] The photograph then found its place in *The English at Home* as the first plate in the important sequence on infancy and the acquisition of language and education[86]—a theme of paramount significance to Brandt.

A Child's Picture Book. In Brandt's personal mythology, in that phantasy text, the figure of the child holds a central position (alongside the body of the woman). The place of the child in his adult imagination was underwritten by a single book from his own infancy, a child's picture book called

Cherry Stones. As a five-year-old, Brandt had been given the book by his parents in Hamburg. It had been published in London, the colored plates drawn by Charles Crombie showing vivid posterlike scenes, each picture corresponding to a position in English society. It took the pattern of the English nursery rhyme, "Tinker, Tailor . . . ," adapted by the leading children's author, Alice M. Raiker. Brandt's copy was miraculously preserved; it was a "charming"[87] talisman to him, a visual mnemonic for that good but lost English childhood. He refocused upon his childhood first during his period of psychoanalysis with Wilhelm Stekel in Vienna in 1927–28 and then again through the premium that Surrealist theory placed upon the sovereignty of infancy, ironically developed from psychoanalytic perspectives. The adult Brandt seized upon the book once more and consciously exploited its rich lexicon of pictures as sources for his photography. In 1981 he admitted: "It was my childhood book(s) that inspired me to be a photographer; it sounds incredible, but there it is."[88]

Cherry Stones is a dark, thin book. On its black cover is an introductory picture in clear, outlined, commercial graphic style: an expository visual language for children and advertisements coined in England by Crane, Dudley Hardy, and Nicholson and Pryde. It was the style of illustration popular around 1900, which in the case of Nicholson and Pryde proved

Cover of *Cherry Stones*

hugely influential on Continental poster designers like Hohlwein. The cover picture shows a young bonneted girl amid a snowbound vista. The girl will be the reader's guide as one moves further through the pictures, just as she looks on our behalf upon the scenes and upon each figure drawn from the ranks of British society. In the front-cover picture, the snow turns all the objects—cottages, figures—into dark shapes upon the white ground. It is once more the world of clearly outlined silhouettes. This is the universe of *Cherry Stones*; it is also

the traumatic scene of Charles Kane's childhood, of the end of his childhood, in fact, in *Citizen Kane*. The film excited Brandt not only because of its profundity of space but also on account of its concealed narrative: the obscured search for the childhood object. Kane's symptom of regression—"Rosebud"—encapsulates the recollected memory of a lost plenitude in infantile experience. Imagine Brandt in the early 1940's, amid his Victorian decorations, his antique oil lamp, the spoon-back chairs, with *Cherry Stones* nearby, saved. He might well feel kinship with Kane, who also wished to recall and rediscover his past through a sign: his snow sled, painted with the name "Rosebud." How similar are those two objects of childhood fantasy—both graphically decorated, both threatened by flames (the incinerator in *Kane*; the fires of the London Blitz for *Cherry Stones*: the very fire raids that triggered Brandt's disabling diabetes in 1941). Across both objects are blazoned old-time, old-fashioned words, the keys to memory, to infancy: "Rosebud" and *Cherry Stones*, displaced tokens of a lost union with the mother's body.

It was a very knowing regression, for Brandt: one that bound childhood and "Britain" together with the act of remembering and the act of photography. He wrote this out as a credo in 1948: "It is part of the photographer's job to see more intensely than most people do. He must have and keep in him something of the receptiveness of the child who looks at the world for the first time or of the traveller who enters a strange country."[89] Brandt, of course, identifies intensely here with both these metaphoric figures, for he is both child recalled and pilgrim to a "strange" yet familiar country.

Cherry Stones corresponded to the divinatory aspect of the children's rhyme "Tinker, Tailor . . . ": placing fruit stones round the rim of dessert dishes and counting them off to the rhyme, eventually discovering one's future place, social station, as an adult; or discovering, as in Alice M. Raiker's version, whom one would marry. And Brandt's credo above ("to see more intensely") seems to nominate the photographer as a *seer*: one who also may divine. This rhymed well with the playful component of *Cherry Stones*: Tinker, Tailor, Soldier, Sailor, Rich Man, Poor Man, Beggar Man, Thief. To spring from place to place in British society was exactly Brandt's intent with his comparative representation of class, career, and generational positions in *The English at Home*.

Types and Stereotypes from the Theater of British Society.
Besides the Audubon bird, the Dali reproduction, and a Degas lithograph of ballet dancers, only three photographs were framed upon the walls of Brandt's Hampstead flat in the late 30's: a Man Ray nude; his photograph of Rackhamesque, hobgoblinlike children in a Bradford street;[90] and an interior with a dirty-faced little boy, an unemployed miner's child from Jarrow with a large pudding basin and empty plates and dishes[91]—bereft of cherry stones. The last photograph was used in *Lilliput* in 1939 as one part of a contrasted pair in a spread. In this, the miner's son from Jarrow stood opposite the infant heir to an American fortune, Lance Reventlow, with the caption "Rich Man's Child/Poor Man's Child."[92] This caption, written in the offices of *Lilliput*, was part of a definite rhetoric of social differences that had some currency in the 30's genre of documentary. Brandt enters this discourse, but

with a concealed phantasmic project: to picture his nursery rhyme schemata.

To bolster this discourse, he additionally used long-coined textual and figural stereotypes from the archives of British culture. For instance, the iconographic figures of *A Night in London*—prostitutes, theatergoers, night workers, policemen—were well sedimented in the British imagination as stock figures in an imaginary nighttime London. These were already stereotypes in the beginning of the 20th century, found in illustrated books like George E. Sims' *Living London* (1902). This book displayed a cast of top-hatted toffs, market traders, and flower sellers meeting on the spectacular terrain of "Midnight London."[93] For his "documentaries," Brandt mobilized this well-established, conservative social typology drawn from the Edwardian dioramas of *Living London* and *Cherry Stones*. Brandt's "Bobby on Point Duty," the flower seller from "All A-blowin' and A-growin'," and the soldier in "Sunday

All A-blowin' and A-growin'

Afternoon"[94] lie in that vast discourse of "London types." This was the title of William Nicholson's 1898 picture book of single, flat poster silhouettes—Barmaid, Soldier, Flower Girl, and Policeman—a book like *Cherry Stones*, but straddling both the adult and the children's market. A kind of lexicon of representations of British society begins to emerge, in profile, within this discursive field. In the 1930's the propagandist for the British Empire, Sir Stephen Tallents, called for "national projection" in the media, which would stress during the period of the Depression "the standing raw material of England's esteem in the world."[95] In his tract, *The Projection of England* (1932), Tallents outlined what might compose the iconography for such British propaganda. The Derby, Piccadilly, the Metropolitan Police, and London buses were cited, all of which Brandt employed in *The English at Home*. These were the received, manageable, and spectacular ele-

ments for representing England. But against them, while celebrating these institutions of the "old time," Brandt and Brian Cook, his publisher, pitted counter-images: pictures of a Dickensian squalor and deprivation, pathetic and grim. Brandt's rhetoric of darkness traced black pits in the East End, a picturesque social underworld.[96] Thus in *The English at Home*, the two Englands gaze at each other, even on the book's front and back covers. The upward look of the East End children on the back reproaches the peering Hohlwein-esque Ascot racegoers on the front cover; Brandt gives us a play of looks about power that is inscribed on his own sense of divided spectatorship.

The tendentiousness of these contrasts led to complaints by reviewers: "Mr. Brandt has hammered his point till it is in danger of being blunted."[97] The unease arose from Brandt's use of one genre—the celebratory picture book, the national guide, and the collection of types and stereotypes of the nation—and his subversion of it by critical juxtapositions.[98] *The English at Home* functioned as a kind of "host genre." The notion of such a "host genre" has been recently outlined by Heather Dubrow in relation to literary formats that act as "hospitable environment[s], for the other form or forms that are regularly incorporated within them. In some cases, for example, the host may assume the function of a screen, hiding or countervailing certain less desirable effects . . . help[ing] to screen their role as satires."[99] The satirical Brandt, who had learned the lessons of Karl Kraus' satirical magazine *Die Fackel* from Vienna in the 20's, was certainly active in *The*

God Save the King!

English at Home. The framework of social position represented, labeled, and sealed by the salute of top hats at the book's close, with the caption "God Save the King!," was, he said, ". . . somewhat a little ironic"[100] in intention.

A Family Album. In *The English at Home*, there are public schoolboys who, in black swallowtail morning suits, doff their toppers to salute a royal visitor or a society spectacle. Children's gazes like these are an important theme in *The English at Home*. Children look out from basement windows, at other

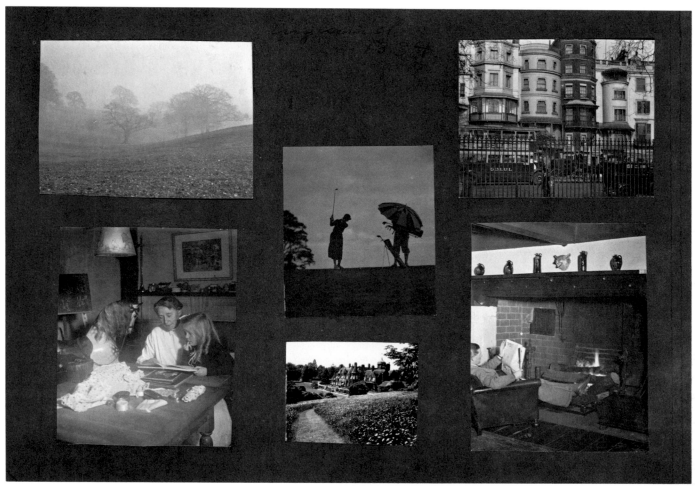

Page from Eva Boros' scrapbook: "England, 1934"

images and at portraits of the Royal family in stationers' windows. In "Nursery Girlhood"[101] they gaze at children's picture books, returning, as an inset *(mis-en-abŷme)*, to *Cherry Stones*. "Nursery Girlhood" reenacts and recalls the nursery as a specially invested imaginary site for Brandt. His photograph of a ringleted girl and her governess reading together was taken at one of his uncles' houses in Mayfair, with Brandt's niece acting the part of Alice. It was a piece of nursery theater, a family tableau. The photograph was placed in Brandt's wife Eva's album under the heading "England, 1934." Indeed, a very great number—perhaps the majority—of the photographs that make up *The English at Home* (and *A Night in London*) are posed by his English family,[102] by his father, brother, sister-in-law, various nieces, and his wife, staging and restaging residual memories and childhood phantasies under his direction of their family dramatics. Brandt reshaped his family back into his nursery text—and into his photograph album too. For it was there, in Eva's album, that the elements for *The English at Home* took shape as part of the album's continued memorializing of their new life in Britain from 1933 on: The Brandts at Home. The flower seller at Belsize Park, the boys at Eton, the gypsy "David Copperfield"—photographs destined for *The English at Home*—were all here first, in this private realm, on a single photo-album page.

Brandt added photograph to photograph in the construction of the memory of London in June 1933 (the inscription on the cover page) before the album's translation into the public, published version three years later. The master template was the pictured scenes in *Cherry Stones*: the tailor sewing, the soldier swaggering, the sailor on display.[103] All were in *The English at Home*; all were to be read privately—by Brandt and only two or three of his immediate family—against their corresponding plates in *Cherry Stones*. Those scenes that he could not stage within his family circle he sought out in London and in Britain in general, discovering human *objets trouvés*. He divined them by Surrealist sensibility, by chance encounters—the method outlined by André Breton in *Nadja* (1928). His brother Rolf described Brandt's method: "He would walk about London observing, and when he found something or someone, he would observe from a distance; then, later, he would try to re-create the scene which had gone."[104] The inscription of loss, distance, and scopophilia (the desire to see)—the presence of absence—is to be found thematized here in Brandt's very method. Rolf, sharing his brother's fascination with *Cherry Stones*, was walking one day in 1935 on Mortimer Street in Soho when, with that Surrealist surprise of the *merveilleux*, he discovered the living simulacra for the colored illustration of the Tailor. In a shop-

window, on a raised platform, exactly, uncannily, as in the book, was the same bald and bespectacled figure. Bill was quickly summoned; he arranged, directed, and matched the tailor into the same pose as his figural counterpart and photographed him.[105] This kind of modus operandi was part of a hallucinatory, obsessional pursuit of *das Unheimliche*; for the uncanny, wrote Freud, "leads us back to what is known of old and long familiar."[106] Brandt pursued the phantasms of childhood like Emma Bovary and her "World in Pictures."[107] He restaged and doubled them through photographs and restored them to a collected life in new albums and books, creating images of images, circulating, reiterating: *The English at Home* dreams *Cherry Stones*.

The Curious Child. Zwemmers, the London publishers, rejected Brandt's dummy of *The English at Home* on the

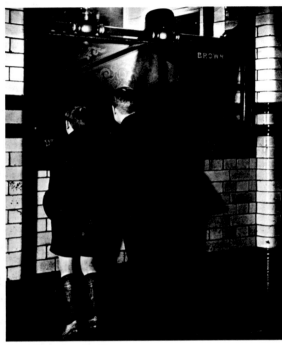

Boys Peeping Inside

grounds that there was "nothing erotic."[108] But there was an element of transgression in Brandt's activity, in his fetishes, in his pursuit of the image of the image. The transgressive image: Besides *Cherry Stones*, besides Arthur Rackham's illustrated books, the Brandt brothers' favorite nursery book was Beatrix Potter's *Peter Rabbit* (1902) with its soft vignettes of prohibition, trespass, and anxiety-laden territory. The forbidden image: While still children, the brothers one day found that the new issue of their beloved *Das Plakat* had disappeared. When their parents were away they searched the house and eventually discovered it. The magazine had been hidden because of some "mildly erotic" illustrations.[109] The search anticipates, in its uncovering of the pictured, forbidden woman's body secreted in a room, Brandt's engagement with the image of the "forbidden chamber" in his late 40's photographs of nudes. There seems to be good reason to believe that Brandt would have recalled this episode to his analyst Wilhelm Stekel in Vienna in 1927–28. Stekel's heterodox psy-

choanalysis focused upon such infantile transgressions. He wrote: "The child's curiosity and exploratory drive are endless. Almost every fairy tale contains a passage dealing with a forbidden chamber and the illicit entry into it, a transgression which, as a rule, is punished severely. The child's early awakened sexual curiosity is the root of his exploratory drive."[110] Stekel's comments were a source for amazed wonderment by Brandt. After each session, Brandt would drive from Vienna, out to the village of Salmannsdorf, with Rolf and a friend, appreciatively discussing Stekel's intuitions.[111]

Out of these analytical sessions Brandt may well have created a further set of phantasms, conscious now of his private mythology, and annexing Stekel's metaphors. The door ajar, the illicit gaze upon the woman's body, and the room's interior magically opened: these are the elements of his late 40's nudes. The curious child of the master narratives of Stekel/Freud/Lewis Carroll/*Cherry Stones* becomes one of Brandt's key representations; boys peep in at the window in *A Night in London* and *The English at Home*.[112] As a detached and distanced observer and photographer, Brandt actually incarnated this figure on the verge, as an intruder, in the uncanny interior of Loos' Haus Möller. Brandt possessed a fascination for the willful transgressor; besides the curious, bewildered child about to view the "forbidden chamber" and its contents, he also identified himself with an intruder of rooms by night: the Thief from *Cherry Stones*. This was the final, dark illustration by Charles Crombie in the book, an underworld stereotype with glinting eyes (like the miners in *The English at Home*) at night, in the act of climbing and crossing a wall, breaking into a polite interior from "his home in the slums."[113] As a child Brandt had begged his mother to point out in the street these strange, special beings from the text: "Show me a thief!"[114] Disclosure was at stake; the child's story; the phan-

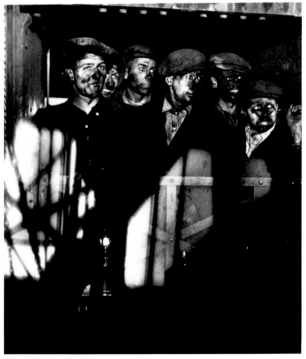

Miners Returning to Daylight

tasm. Stekel's paradigm of the forbidden chamber in the fairy tale was taken up by Brandt in his suggestions to Chapman Mortimer for the contents of the introduction to *Perspective of Nudes* in 1960. In his writing for this there comes a point where Mortimer concedes that the status of the nudes is ambiguous, that they are textual: "... for these are not nudes, they are *contes de fées* [fairy tales]."[115] It is within these themes that Brandt's 40's and 50's nude photography can be figured in phantasmic terms: the thwarting of patriarchal authority; the bewitching, petrifying, and petrified woman; confining rooms that frame and fix the body within; doors giving onto secret chambers; the night dreams of a curious child; and rhymes, nonsense, fairy stories, and their picturing.

III. BEYOND THE SOCIAL

Brandt's erotic text first becomes apparent before the nudes in *A Night in London*. This is a book of assignations: couples in the dark; the eroticism of the metropolitan night. The theme of the night-watching voyeur—who is photographer and the book's spectator too—is present. In Brandt's 1951 essay "Pictures by Night," this motif of nocturnal transgression and voyeurism comes to the surface of his writing intermixed with his prescriptions for the mechanics of night photography.

> After midnight, in particular, there is hardly anybody about, you can do almost anything without being disturbed. There are rarely any watchers, and you are seldom troubled even by passing cars. Night photography can indeed be a quiet and pleasurable sort of game. But if you go after night life, it can also be an exciting one. There are the people, waiting for other people or pursuing their various (and sometimes shady) occupations, the sleepers on park benches who have nowhere else to go, the busy pleasure seekers of the fashionable centre of town, the neon signs and the traffic. And the night photographer weaves his way in and out among the quiet and the busy life, watching without being noticed, catching glimpses of everything.[116]

Who watches the watcher? The patriarchal figures of the Law, those emblems and effigies of authority that had been evident in *The English at Home*. Bobbies, Soldiers, Sailors, and Schoolmasters are not so prominent in *A Night in London*; they are, literally, in the background watching the "shady" characters.[117] The exception is *A Night in London*'s cover: a Hitchcockian bobby, helmeted and caped, telephoning Scotland Yard from a dark, flashlit street. But the transgressors—thieves, prostitutes, tramps of both sexes—are prominent in their stead.[118]

The Nude and the Name of the Father. Brandt's gaze became manifestly settled on the (transgressive) nude in the mid-40's; nevertheless he still invoked a figure of authority for what he considered to be his first successful nude composition in the summer of 1945,[119] when he provisionally titled it "The Daughter of the Policeman." With this supremely Hitchcockian title, patriarchy returns, albeit out of frame and beyond the intimate room with the woman's body in it. Brandt's great anxiety for the following decade—coming to a crisis around 1955—was his fear of the response of figures of authority to his nude photographs. Witness his anxiety in the face of Steichen's jurisdiction. If Brandt forms his figures of desire with the late 40's and 50's nudes, then they already carry the disfigurements of the phantasmic order. Childhood imaginings become confinements within the *costruzione legittima*,[120] the orthodox perspective of the caging, claustral orthogonals of the Victorian rooms. Painting in London at this date, Francis Bacon separately developed a similar tactic of "enclosure" within those framing constructions.

"Phantasy exists because desire bears within itself its prohibition, because—in Freudian terms still—desire can only be fulfilled in a regressive manner, through the formation of phantasies."[121] So beside the curious child and the woman's (mother's) body, there stands a third figure in Brandt's imaginary family: the paternal figure, before whom Brandt's phantasms must be reassuringly domesticated (like *The English at Home*) in the room and house of the father. It was

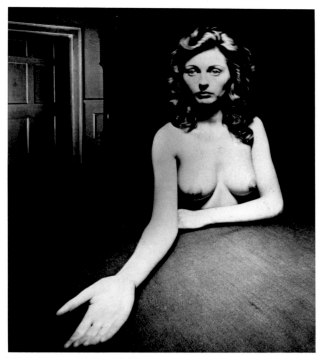

Micheldever Nude, 1948

surely no coincidence that the uncanniest of the late 40's nudes, "Micheldever Nude" (1948)[122]—a sphinx-faced chimera gazing gorgonically at camera and spectator, her right arm extended in demand—was photographed in a darkened room, with door ajar, in Brandt's father's house. For there, at the table, the anamorphic projection of Brandt's 6x8 view camera distended and attenuated the model's arm into an anxiety-provoking vision of the power of the Father and the disclosure of the Woman's body. There, traced out like the enigmatic skull in Holbein's *Ambassadors* (1533) or Dali's soft objects, is "the phallic ghost . . . the imaged embodiment of . . . castration."[123]

The Law Monumentalized; Documentary Questioned. The figure of the Law incarnate, the bobby who presides over the cover of *A Night in London* and the second plate of *The Eng-*

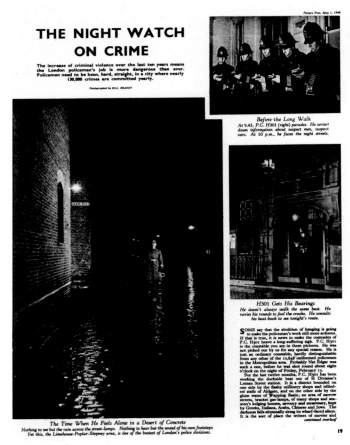

"The Night Watch on Crime," *Picture Post*, May 1, 1948

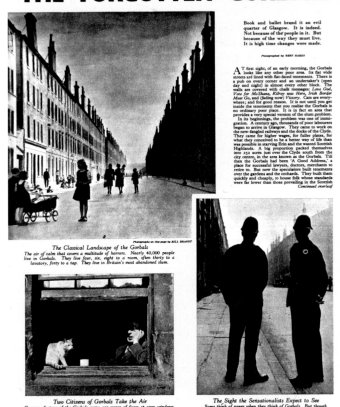

"The Forgotten Gorbals," *Picture Post*, January 31, 1948

lish at Home, besides being a symptomatic index to the Brandtian text, is of course also a fragment of a public discourse. Brandt's 30's policemen were part of a stable universe of assured signs of Londonness and Britishness; hence his deployment of them. In the late 40's he remade them for *Picture Post*. Following the shooting of Police Constable Nat Edgar in February 1948, there had been a social panic centered around youth, firearms, and delinquency; this was the immediate context for Brandt's freelanced photo-essay "The Night Watch on Crime."[124] This was the swan song of his police nocturnes. Police Constable H301 is surrounded by darkness; rain glitters across cobblestones, loiterers are moved on, and windows are peered into. It is the moment of the high-contrast Ealing Studios' film on police and delinquency *The Blue Lamp* (1950).[125] But something in Brandt's code was out of joint with the populist representations that filled *Picture Post* and *The Blue Lamp*. His pictures were monumental and full of Brangwynesque pathos—elements at some distance from the orthodoxies of the populist photojournalism of the 40's. This led to a break with *Picture Post* on Brandt's part, coming at the beginning of 1948 when he was commissioned to photograph the Gorbals tenements and slums in Glasgow. When the story was finally published as "The Forgotten Gorbals,"[126] only three of his pictures appeared on one page of the six-page article. All the other photographs were by Bert Hardy, the robust *Picture Post* staff photographer who had been dis-

patched to Glasgow to replace Brandt. The decision to replace him had been taken by the editor, Tom Hopkinson, once he had glimpsed the contacts from the pictures Brandt had shot.[127] These showed Surrealist vistas of de Chiricoian streets and silhouetted statuesque policemen; they were photographs that had to be given monumental connotations by the *Picture Post* caption writer: "The Classical Landscape of the Gorbals."[128] The distance and strangeness of Brandt's Gorbals pictures were utterly different from Hardy's humanitarian populism with its point-of-view close to the scene, discovering picturesque families, communities, and pub life. It signaled the end of Brandt's association with documentary photojournalism.

A Body Beyond Documentary. In truth, once Brandt's "documentaries" as a whole are dislodged from that fixed and narrow category of photojournalism, their other meanings might be recovered. There is that other, continuous, symptomatic text that we wrote of at the outset, one whose themes know of no division between the received, delimited spaces composing that litany which runs: documentaries, blackout pictures, landscapes, portraits, nudes. These reductivist classifications were first applied to and constructed his work in the division of *Shadow of Light* in 1966. Once this model is deconstructed, then other configurations emerge. Chief among such discovered themes would be Brandt's discourse surrounding the woman's body. Nowhere does this erotic text shine through more than in Brandt's freelanced photo-stories

86

about women in service industries that were published in *Picture Post* in 1939: "A Day in the Life of an Artist's Model";[129] a waitress, "Nippy: the Story of Her Day";[130] "A Barmaid's Day";[131] and finally "The Perfect Parlourmaid."[132] This set of "documentaries" took the matrix of the day—the cycle from waking to sleeping—that had been the narrative format of Ruttman's *Die Symphonie der Grosse Stadt Berlin* and Brandt's own *The English at Home*. (They progress through one night—that other, dreaming fantastic side of quotidian day that was, of course, the plan of *A Night in London*.) Such narrative patterns were well established: the "day in the life" story was commonplace in *Picture Post*, carried over from standard German photojournalist practice by its first editor, Stefan Lorant. In this series on women in service jobs, Brandt orchestrated a sequence on a woman's body variously identified, unclothed, decorated, or uniformed; passing publicly through the day's labor and into her private world of dancing, cinema, and bed again. "How she lives . . . How she works . . . How she spends her spare time. . . ."[133] The four stories are distinct from the *petits-métiers* (small-trades) aspect of the social types paraded in *The English at Home*. The model, waitress, barmaid, and parlormaid were women marked by nudity or uniform for specific exhibition; Brandt privileged, centered, and displayed them as fetishes, as flat posters of themselves. Pratt—his uncle's parlormaid—becomes, in the process of his photo-story, a de-corporealized pattern of white and black in her uniform. Thus the four stories drift from the social domain to the phantasmic, exceeding their "documentary" positioning. In a similar vein in *A Night in London*, while citing that documentary paradigm of bad housing conditions in the caption to a plate—"Dark and Damp are the Houses in Stepney"[134]—Brandt's photograph depicted an erotic, romantic icon of a prostitute floating, detached, framed, white, another chimera in a window above a midnight mean street. This figure from Symbolist imagination and iconography at the turn of the century is relocated in the 30's "host genre" of documentarism.

Perhaps Brandt's sleepers in the deep shelters of the London Blitz also exceed the meaning assigned to them, no longer signifying "wartime documentaryness." Perhaps they have meanings in the Brandt text other than standing as exceptional governmental records for Home Intelligence. The motifs of an intimate immensity, of the expansion and proliferation of the body in dreams, are present in the shelterers in "Deep Below the Ground."[135] But they are present too in the late 40's nudes. There are shared elements between the shelterers and the 1947–49 nudes: sleep; immobility; the dark, enfolding secret chamber; and the displacement of the world for the (sleeping) body. "*Prendre pour monde le corps*."[136] The bodies of the Barmaid, the Model, the Waitress, and Pratt seem to expand to dominate the world that was to be "documented." In Brandt's topology there are havens of sleep and dreams; within them the bomb shelterers' bodies multiply[137] in panoramas of "intermingled bodies,"[138] as he wrote at the time. Like the architecturally enclosed nudes of Delvaux, Brandt's nudes of the late 40's grow large, monstrous with sleep. This giantism fascinated Brandt. We have already marked his imitation of Brassaï's 1934 nude as a landscape,

"Ciel Postiche," enlarged like Lewis Carroll's Alice, enormous and compressed against the confining frame of the White Rabbit's room. This is how the nudes of the late 40's, in Brandt's rooms at Campden Hill and Hampstead, come under our gaze. Their context lies, too, in Stekel's clinical metaphors of regression to an inter-uterine[139] state and Loos' "warm and welcoming space."[140] Both nudes and civilian shelterers are under threat of annihilation, "protected," in Stekel's words, "from the inclemencies of the outer world."[141] The themes of reverie and protective intimacy play across these photographs. But in that age of anxiety and inner exile, the pictures

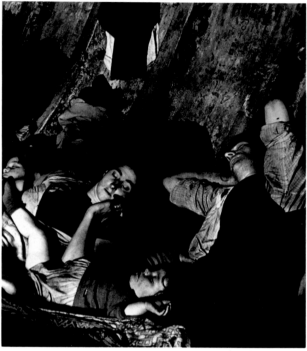

Crowded improvised air-raid shelter
in Liverpool Street tube tunnel

of both nudes and bombed civilians are, we may say, pictures of refuge: *sheltered* photographs. They body forth that topic at the displaced center of the Brandtian text, that which we set out to reclaim—the withdrawal into a phantasmic universe bounded by a dark interior.

Toward the Erotic Body in Brandt. Humanity asleep, enraptured, prostrate, sunbathing,[142] down and out, collapsed against a fence at Ascot,[143] or sleeping in the Salvation Army hostel;[144] embracing lovers on park grass;[145] bodies, inert and horizontal, are spread across *The English at Home* and *A Night in London*. In both the "shelterers" series and *A Night in London*, figures are returned to their beds like children sent to read their picture books,[146] like the flattened, foreshorted hospital patient in *A Night in London*.[147] With the exception of Brandt's anamorphic volumetrics of the nudes, his bodies are as flat as a sign. We have seen the duplication, repetition, and exchange of flat sign and body with Brandt's erect Sailor Cox in *The English at Home*.[148] But Brandt's flattened and prone representation of figures deliberately alludes to specific texts: to Lewis Carroll and John Tenniel's representations of the fictive population of *Alice in Wonderland*

87

and *Alice Through the Looking-Glass*. Brandt insisted[149] upon the relevance of his reading of *Alice . . .* and the importance of its text *and* illustrations to *The English at Home*. (Carroll's prototype illustrations created to guide Tenniel were also seen by Brandt since they were published in *Minotaure* at that time. They included the cabined and confined Alice exceeding her room frame.)[150] *Alice*'s spatial phantasies, Brandt said, were put to good use in the recumbent figures in the foreground of "Derby Day," flat on their faces, and complementing the vertical Sailor Cox on the opposite page.[151] Here, too, were the sprawling Eton boys at a ceremonial cricket match, re-

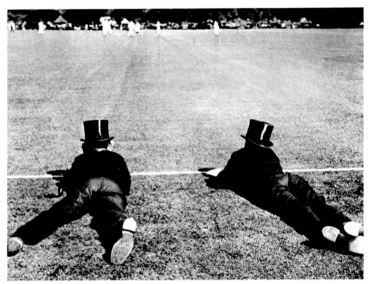

Eton Sprawls

sembling the three gardeners at the beginning of Chapter VIII of *Alice in Wonderland*. "The three gardeners instantly threw themselves flat upon their faces"; at this Alice wonders: " 'What would be the use of processions', thought she, 'if people all had to lie down on their faces.' "[152] In *Alice in Wonderland* such flatness removes social differences, making one body indistinguishable from other, perhaps more differently ranked, bodies. " 'And who are these?' said the Queen pointing to the three gardeners who were lying under the rose-tree; for you see, as they were lying on their faces, and the pattern on their backs was the same as the rest of the pack, she couldn't tell whether they were gardeners or soldiers or courtiers, or three of her own children."[153] The clear social signs have disappeared, disturbing the Queen of Hearts. Anonymous flannel-trousered and sports-jacketed male bodies sprawl on the grass at Epsom and in Hyde Park. But Brandt's fondness for the cultural disorder of signs in *Alice in Wonderland*—that which the Surrealists had found to admire in Carroll—was countered by his equal love for "procession," that round game of social differences emblazoned in the pictures of English effigies in *Cherry Stones*. For in *Cherry Stones*, social identity is manifest and never at risk, while in *The English at Home* the exhibition of social position is playful, ludic. In both *The English at Home* and *A Night in London*, resting, nursing, death, and a midnight vigil in the hospital are clustered together as plates,[154] as recollections and simulacra of

five years of sanatoriums. Yet within Brandt's general iconographic field, that horizontal body is primarily an erotic body. At the end of a Neo-Victorian photo-essay for *Lilliput* in 1939 called "Unchanging London," Brandt's Hyde Park lovers[155] reappear (they were actually his brother Rolf and wife). In the context of the article, the embracing couples at dusk are linked to the unchanging status of desire. Time is suspended in the concluding caption: "And this London scene was the same in 1872 as in 1939 and will be the same in 1972 and in 2039."[156]

The thread of the continuing narrative of the metropolis is the erotic. This same tactic was used by Brassaï and the film maker René Clair in their treatments of Paris in the early 30's. In *Sous les Toits de Paris* (1931), Clair especially showed the erotic to be the resolving factor that organizes the subworld of the *apache* and *voyou*. In the 30's and then in the 50's, Brandt places his lovers, nudes, and reclining women outdoors. In the 40's, the erotic haven is the paradigm for his interiors. Its onset is marked by the inclusion of "Top Floor" in *A Night in London*,[157] which Brandt later retitled "Soho Bedroom." It is the primal scene that cameraman and spectator peer upon. There is the tableau: a bedroom corner, a bed, and the silhouetted lovers. Man and woman become part of a set of polarities of black and white that range over the whole picture, like cubist monochrome geometries. Certainly Michel Butor read the plate in this way. He addressed the male as an Indian, another of Brandt's darkened men:[158] ". . . bel Indien perdu dans notre île, auras-tu jamais été caressé par des mains si blanches et si longues?" ("beautiful Indian lost in our island, will you ever have been caressed by hands so white and so long?")[159] Brandt had cut out pictures of brothel scenes for his *Kleberbuch* ten years before. Now he censored and domesticated "Top Floor," and made it more reassuring by adding mistletoe to the top center at the frame's edge, excusing its erotic motif. He retouched and eliminated the mistletoe in his 60's prints of the negative. The immediate source for "Top Floor" was one of Paul Eluard's collection of postcards that had been reproduced in *Minotaure* (once more his great resource).[160] This showed an entwined couple, the man in a suit of armor and the woman's arms naked. As in the postcard, the male in "Top Floor" is a black silhouette, anonymous from the back, a species of the dummy, that mannequin that nearly always stands in for the female body in Brandt's iconography (a type that began with Brandt's first Surrealist contribution to *Minotaure*, a photograph of a Paris flea market appropriately entitled "Mannequin").[161] The slumped head of the male in "Top Floor" has the specific pose of another mannequin that was canonical to Surrealism and to Brandt: de Chirico's dummies, seen from behind with heads to one side in the closed rooms and architectural settings of his 1914–15 Parisian paintings.[162]

The Romantic Margin of the Erotic: Brandt and Kitsch. Before Brandt abstracted the erotic from the domain of the social, where it is still tenuously located in "Top Floor," and enclosed it in the bereft bourgeois (Neo-Victorian) interiors of the nudes from 1945 on, he experimented with more marginal representations. One rejected tactic was to follow Brassaï and literally represent the woman as prostitute—to make a tableau

of prostitution. In January 1933, Brandt posed his new wife, the photographer Eva Boros, as a streetwalker in the Chinese quarter of Hamburg, in front of a Chinese neon sign. Here the stereotypic erotic "other" of Orientalism conjoined a fragment of metropolitan exoticism. Brandt turned to a high Romantic erotic iconography as well, framing women in windows overlooking forlorn vistas, an anachronistic[163] mock chivalric image that he relocated in suburban London and the East End.[164] It suffices here to point out the Surrealist irony Brandt brought to such iconography. Indeed the representation of the prostitute hovering in the air, in the window in Stepney,[165] belongs to the same kind of Romantic fantasy that Emma Bovary entertained. "She would have liked to live in some old manor house, like those deep-bosomed châtelaines who spend their days beneath pointed arches, leaning on the parapet, chin in hand, watching a cavalier with a white plume galloping up out of the distant countryside on a black charger."[166] With just this kind of Flaubertian irony Brandt captioned his flash photograph of a couple kissing in a wartime nightclub "Paul et Virginie,"[167] the title of one of the most popular post-Rousseauian 18th-century French novels by Bernadin de Saint-Pierre, a novel that hailed the supremacy of Romantic love.[168] This had also been cited by Flaubert's Emma as a paradigm of Romantic erotic imagining in *Madame Bovary*. Perhaps a genealogy of Romanticism in Brandt might disclose the place of another excursion into romantic kitsch for *Lilliput*, titled "A Simple Story of a Girl."[169] This awkward photo-essay about a soldier and a girl meeting and falling in love in a park intermixes starkness and sentiment in a manner that may well indicate Brandt's debt to the late 19th-century novel *Viktoria* (1898) by Knut Hamsun, a writer he admired. "A Simple Story of a Girl" is kitsch in its suburban ecstasies, but to leave the case at that would be to ignore the long and provocative complicity in Surrealist visual poetics between photography and sentimental mass culture. It was concerning Boiffard's and Man Ray's photographs in Breton's *Nadja* (another key book for Brandt) that the critic Walter Benjamin observed: ". . . photography intervenes in a very strange way. It makes the streets, gates, squares of the city into illustrations of a trashy novel."[170] For Brandt as well, romantic kitsch could be redeemed by the agencies of desire, by a Surrealist imperative.

IV. THE CULTURE OF CATASTROPHE

As a metropolitan pastorale, "A Simple Story of a Girl" was typical of many of Brandt's routine commissions for *Picture Post* and *Lilliput* in the early 1940's. These were to represent wartime Arcadias, recreative pastorals for relaxing war-weary readers; see also "A Day on the River,"[171] "Dancing in the Park,"[172] and "Holiday Camp for War Workers."[173] With "A Day on the River" he turned to his grounding in European literature, in particular to the elegiac naturalism of Chekhov, productions of whose plays had been Brandt's favorites in the London theater of the 30's. Brandt had already deployed Chekhov's scenography in the picture of absorbed after-dinner conversations among young intellectuals in *A Night in London*.[174] He reengaged, as well, with de Maupassant's idylls of boating and love by and on the Seine, and repictured them in "A Day on the River" by the banks of the rustic Thames. It was a poignant, wartime Arcadia that Brandt represented in 1941, of human relations played out on the brink of catastrophic change.

Terminal Landscapes. These photographs, we should remember, were Brandt's landscapes with figures. The vast majority of his pastorals were unpopulated or, rather, depopulated by war. He was to say of wartime Britain's landscape: ". . . it was very strange . . . it was particularly good because it was war and nobody travelled; there were no signposts."[175] This fitted exactly his drive toward an uncanny construction of rural Britain. From 1941 until late in the war he worked for the National Buildings Record. He documented ancient buildings in old English towns like an antiquarian topographer employed by the state to record the dislocated and archaic remains of the past, which Brandt metaphorized like the great neglected private sculpture garden at Plas Newydd that he photographed in 1944.[176] Over and over again, it was the "fantastic"[177] which attracted him to the English landscape as an object of desire—an object that was threatened by destruction. At the time of Brandt's "Bomb Shelter" photographs it had been agreed by the wartime Ministry of Information that with the threat of aerial mass destruction by the Nazis, the aim "should be to make a record of all meritorious buildings."[178] Brandt's job was literally to conserve, through his photography, a culture threatened by obliteration. And this reparative element had been, even before the war, the motor for his first British landscape photographs—the cherished, surviving objects, fetishes of the body of Britain, like the figureheads of old sail boats he had photographed and preserved in the Scilly Isles in August 1934. These were sculptural dummies of women and men, like Sailor Cox, standing amid a rocky landscape garden. He sold these pictures to *Minotaure*.[179] To Brandt, landscape was a ruined garden or cemetery to be recorded, "documented"; yet it signified Surrealist disruption and "presence" as well. This fundamental ambiguity is present in his photography of Victorian statuary from 1939 on: fetishes of the past.

Excursus: "Other" Landscapes; Hungary and Spain. In 1932 and 1933 Brandt had been strongly drawn to what might be thought of as Europe's own internal "other." He had been reading the magazine *Der Querschnitt* in a Swiss sanatorium in the autumn of 1924 when he came across Hemingway's astringent poems "The Earnest Liberal's Lament," which he copied into his *Kleberbuch*, and two called "The Soul of Spain."[180] These latter were Hemingway's first response to his extended stay in Spain in 1923. In the poems and in the later novel *Fiesta* (1926), Brandt encountered Hemingway's presentation of a culture utterly untouched by modern industrial civilization. Spain was in Hemingway's words "the real old stuff."[181] For the *Heimatlosen* whom Hemingway satirized in *Fiesta*, Spain was a utopia but also a hard rebuke. Under the power of these texts, Brandt was determined to visit Spain. Not only did that country appear to occupy a position as a primitive utopia, both dramatic and tragic, but it was also the fountainhead of Cubism and Surrealism. For Brandt, during his stay in Paris from 1928 to 1932, the im-

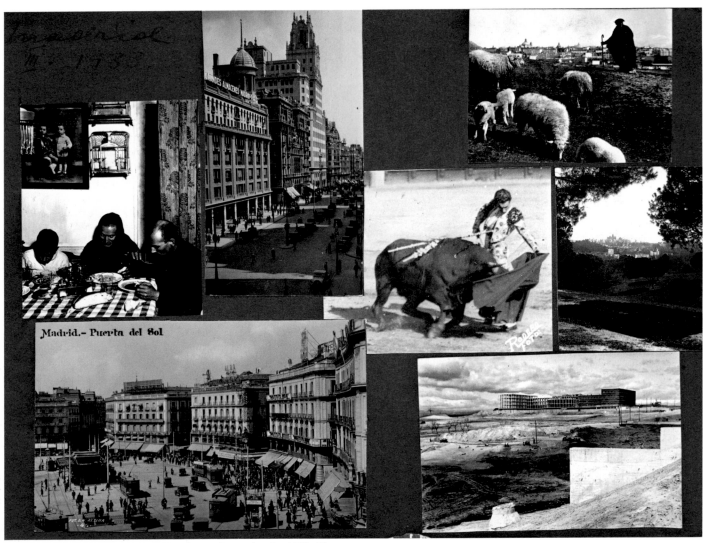

Brandt's visit to Spain, from Eva Boros' scrapbook, 1932–33

portance of such Catalans as Dali and Buñuel (and their contributions to Surrealism in painting and film), as well as Miró's, Picasso's, and Gris' paintings and the architecture of Gaudí could not be overestimated. Brandt learned Spanish and went to Barcelona in April 1932 with a group of four *heimatlosen* friends. He married Eva Boros at the British Embassy there that month.

Up to that point Brandt had produced one or two independent photographs—the flea-market "Mannequin" (1930), for example. But Barcelona in 1932 and a visit to Madrid and Toledo in March the following year marked the turning point in his photography. During this period he created a set of extraordinary photographs: "Spanish Family," "Shepherd Outside Madrid," "Fountain in Barcelona," and "Mendicant". Such is the underdeveloped state of Brandt studies that only one of these photographs is generally known, the "Fountain in Barcelona."[182] "Mendicant" was republished for the first time in forty years in 1981.[183] In these photographs the imaginary Brandtian text of phantom presences, of grim blackened figures and petrified women, is fully inaugurated

for the first time. The photographs of an uncanny Spain announce the onset of the English series that he began only months later in the summer of 1933. Hemingway's "real old stuff" is present: elemental shepherd, beggars, and gypsies under a hard Spanish sun; fragments of a picturesque universe, the pastoral and the transgressive. But in Brandt's visual recoding, they are rendered stark, flat, defamiliarized, and monumental. He photographed "Mendicant" on his way to a bullfight in Barcelona. Jean Genet was in the city that year, down and out and begging. Recollecting that moment in *The Thief's Journal*, Genet wrote ". . . Spain and my life as a beggar familiarized me with the stateliness of abjection, for it took a lot of pride (that is, of love) to embellish those filthy and despised creatures. . . . I wanted to affirm it in its exact sordidness and the most sordid signs became for me signs of grandeur."[184] By reframing Brandt's "Mendicant" in the context of Genet's transgressive heroics, we may come nearer to that *gravitas* that countersigns "Mendicant," or the waif-gypsy boy of the following year, or the "East Durham Miner Just Home from the Pit"[185] whom Brandt photographed in

Mendicant, c. 1932

1937. Figures on the dark side, like the troglodyte gypsies he photographed at Hortobagy[186] on the central Hungarian plain in 1933, recalled André Kertész's idylls of the early 1920's. For the *Heimatlosen* and for Brandt, the edges of Europe—Spain and Hungary—were still fantastic margins in the 30's. They were locations for the "authentic" and "primitive": a strange humanity, untouched by advancing industrialization. Later in 1933, Brandt turned finally to the one other geographical place, his old object of desire in his graphic unconscious, Britain.

No More Arcadias: Life on "Rotting Hill." By 1937 Brandt had sought out Britain's industrial "other"—the depressed "Special Areas," so designated by the National Government, in the North. Ten years on he photographed the rural "other": Skye, Connemara in Ireland, the Gaelic and Celtic fringe, still territorialized against an ever centralizing Britain, and at the edge, seagirt like the Scilly Isles. What is disclosed by Brandt in his Gaelic and Celtic photo-essays of 1947, in "Beauty and Sadness in Connemara,"[187] "A Day in Dublin,"[188] and "Over the Sea to Skye"?[189] A grim cultural pessimism. A great slide into decline, dereliction, and ruin, against which only peasant civilization is asserted. These Gaelic and Celtic photo-essays recall Brandt's melancholy reportage commissioned five years before by *Picture Post*, "Empty Houses." Shot in the early spring of 1942, the images spoke of mist and metropolitan dereliction, of de Chirico's terraces transferred to a neglected, deserted Bloomsbury characterized by, in Cyril Connolly's words, "the gradual draining away under war conditions of light and colour from the former capital of the world."[190] The "body" of Britain, at its center and periphery, is an abandoned ruin. "Sadness"[191] is the pathetic key. In 1951 Wyndham

Lewis summed up this wartime and postwar cultural mood as "Rotting Hill culture." In his book *Rotting Hill* he presented a shifted version of the London district of Notting Hill through a pervasive metaphor of dry rot. Published in the same year as Brandt's *Literary Britain*, it forms a commentary on the encompassing melancholia of that book, with its vistas of the past and its literary texts. Wyndham Lewis wrote: "Decay is everywhere . . . if an aristocratic society suddenly drops to pieces after many centuries and if a mercantile class of enormous power and wealth drops to pieces at the same time, there is, inevitably a sense of universal wreckage and decay as when demolition work is in progress. . . ."[192] The late 40's—this "Rotting Hill" moment—are for Brandt the moment of portraits like that of Constant Lambert,[193] gaunt on a dark rickety staircase like Pinky in the film version of Graham Greene's *Brighton Rock* (1947), or the mournful Campden Hill nude of 1947 that Brandt wanted to call "the little nude."[194] Guignol and loneliness abound: the melancholy interior, a search for exemption from deprivation through claustral erotics or else the spiv pose of the raffish composer Constant Lambert. Small wonder that locations like Eva's flat in the dilapidated Eaton Square in Belgravia appealed to Brandt at this time. They were tokens of "Rotting Hill culture." In his photography of Dublin, Brandt swung through the Gaelic orbit only to find, in his own words, that "most of these tall Georgian houses have now descended to tenement

"Baedecker Raid," *Picture Post,* July 4, 1942

The Eaton Square Still Life, c. 1948

In all his other pictures of this moment, the great Victorian spoon-back chairs— the chairs that bear Alice in Through the Looking Glass *(1872)—carry the nudes, the woman's body and the mother's body, lost and refound. This still life bears other objects that serve to recall Eva once more. It is indeed a kind of displaced lover's portrait. The photograph was intended for Eva and only one print was made. It was perhaps an offering of love.* DAVID MELLOR

level.''[195] A whole world had gone shabby, while Orwell's *1984* (1949) and Carol Reed's *The Third Man* presented versions of living on in the ruins.

For Brandt, Galway in County Connemara is equally a city in decline, sliding back to peasant culture.[196] Despite its "sadness," the land, wrote Brandt in his captions to his elemental photographs, has "a wild beauty."[197] His adamantine pictures of peasant farming have their own particular textual referents to another kind of *Heimat*—both the primeval peasant depicted in the photographs of Kurt Hielscher in Germany in the 20's, especially in his book *Deutschland*,[198] and the pagan ground found in the novels of Knut Hamsun, for which the Brandt brothers had formed such a cult. These books included *Mysteries* (1892), *Pan* (1894), and, most importantly, *The Growth of the Soil* (1921). Moving on to Skye, Brandt found it, like Connemara, cut off from modern culture (which anyway is perceived to be in terminal decline). It is a primeval site again. Lord Macdonald's forest, Brandt tells the spectator in the caption, is to be figured as a memory of a "Romantic painting," presumably by Caspar David Friedrich, with its runic crosses and seemingly prehistoric beasts. Context is paramount here, for this bleak representation of the Gaelic and Celtic fringe was not confined to Brandt in these years. As ever with Brandt's work, it is film—the cinema—that provides the relevant context. The British team of director Michael Powell and producer/screenwriter Emeric Pressburger made the film *I Know Where I'm Going* in 1945. It is set on a remote Hebridean island, like Skye, that barely sustains a contemporary peasant/feudal culture. It is an island of wild animals, ancient castles, and Celtic stones; an atmospheric, haunted place. In 1947–48, George Orwell, whose novels and reportages Brandt had closely read in the 30's, had retreated to Jura, a remote island off the Scottish coast, to live an elemental life. What we might try to describe, in Brandt's landscape photographs of the British periphery, as in Powell and Pressburger's film and Orwell's peasant exile, is a shared cultural strategy in the second half of the 40's in Britain: a forwarding of a distinctive imagination of flight from the urban and the social to "wild" nature, which, in the disenchantments of the late 40's, can never be authentically Arcadian again. It is, then, this sorrowful twilight of the dark eclipsing of a once Arcadian Britain that Brandt chooses to represent in *Literary Britain*. The land of the text is mourned over, passed by. It is a barren, emptied-out landscape, cleared of that animating social parade of *The English at Home*.[199] This seems to be the most poignant element in Brandt's *Literary Britain*.

The End of "The Social." We have, then, to grasp Brandt in the currents of the new cultural climate of the catastrophic 40's. He readily acknowledged that changing configurations in politics and society had erased his project of a highly contrasted, still Victorian or Edwardian Britain, the hierarchized, ritualized society of class gulfs and legible differences depicted in *The English at Home* and *A Night in London*. "Everything changed after the war,"[200] he said. The reformism and welfare state ideology of the post-war Labour Government of 1945–51 fostered the development of a social rationality that held little interest for him. The wartime corporatism and com-

Cover of *Camera in London*, published 1948

munitarianism erased those heightened graphic contrasts of caste—the motor of so much of his 30's photography—which were, in the Conservative complaint, "levelled," "greyed" by state management of the economy. The virtual disappearance of Brandtian reportages in the mid- and late 40's indicates the disappearance of certain imaginary and signified social space. It follows that his departure from social documentary has to be accounted for.

Perhaps Jean Baudrillard's observations are useful at this juncture. He writes of a fundamental paradox: as the welfare state and corporate vision was extended in the name of the social, the authentic space of a heterogeneous society contracted. "The development of those institutions which have signposted the 'advance of the social' (. . . urbanisation, medicine, education, social security, insurance, etc.) erode the actual dimension of the social; . . . it could be said that the social regresses as its institutions develop."[201] The rationality, control, and planification typical of the modern state—just such a one as came into being in Britain in the 40's—had been pointed out as the enemy of the independent *Heimatlosen* by Ezra Pound as early as 1921.[202] It was the projection, too, of Orwell in his extrapolated form of Britain as Airstrip 1 in *1984*. The 20th century finally caught up with Britain in the 40's, voiding that belief that Adolf Loos had held in the 1920's, that the island of Britain was free from that oppressive nightmare of the soullessness of a mass-society future (*Seelenlosigkeit*). Thus, as the institutions of the modern

93

state advanced in Britain in the second half of the 40's, so Brandt shrank from the spectacle of the social body. It was no longer claimable as a fantastic wonderland composed of *Cherry Stones*-like types. We might say that Brandt regressed further, to the interior and the isolated woman's body of the late 40's nudes.

This privatizing of social and political sentiment was, for Brandt, already under way from the very beginning of the 40's. We should not mistake Brandt's cultural politics or the changes they underwent in the 40's. As George Watson, the cultural historian, has observed: "The year 1939 is surely the most important of all in focussing the gradual phenomenon of loss of faith"[203]—loss of faith, that is, in the political systems of the left. Brandt had sympathized with the radical left. He even exhibited at Marx House,[204] but he never joined any political organization. The Nazi-Soviet pact of August 1939 affected him greatly. "It was the end of it"[205] for him, and the credence he had once placed in the systems of the left began to weaken. Along with his crumbling loss of faith went, by implication, an acute questioning of the place, and primacy, of realist reportage and Documentarism. It was that commonplace 30's left aesthetic of art "reflecting society and reality" that Brandt was to indirectly assail in the introduction to *Perspective of Nudes*. Writing of mimetic perspective and optical systems, Brandt declared his wish to go beyond prescribed forms of verisimilitude to surpass the Humanist model

Illustration by John Tenniel from
*Through the Looking-glass and What
Alice Found There* by Lewis Carroll

of optics; the object of his scorn was displaced and allegorized as those mechanisms that "reproduce life like a mirror."[206] Like Carroll's Alice, Brandt now wished to "enter the mirror" and transcend the Realist text.

The Phantom in the Doorway. We have already seen Brandt exceed Documentary Realism with those catalogues of phantasy *The English at Home* and *A Night in London*. His adherence to a Realist text was deeply fissured, disclosing the figures of the woman's body, childhood, the obvious fictive-

ness of his tableaux,[207] and strands of Surrealist codes. Brandt's two books of the 30's verge on deconstructing themselves through the pressures of their "warring forces of signification."[208] The Documentarist paradigms in *The English at Home* and *A Night in London* are riven by varieties of counter-realism. Tom Hopkinson touched on the tension between these "warring" modes of representation, between documentary and its ethical and social dimension on the one hand and Brandt's irrational phantasy projections, his phantasms, on the other. Hopkinson claimed, in 1942, that Brandt possessed " a sense of justice and social contrast, a keen edge of beauty, an entire absence of cynicism or contempt towards one's fellow human beings [and] *a presentiment of the phantom in the doorway.*"[209]

It was just that mentality that he transmitted to Robert Frank at the close of the 1940's. Brandt was an exemplar for Frank, and Frank grasped Brandt's tactic of displaying typical clothing signs on the body. The black-top-hatted silhouettes of stock exchange jobbers that Frank photographed in London in 1951 bear Brandt's imprint, as do his other motifs from 1951: the funerary and the sinister graveyards and streets; the angelic, petrified women/statues; the iconography of death and the child. These *memento mori* follow on from Brandt's photograph of children playing among the gravestones in Burslem cemetery in 1937. Frank took from the Brandtian structure of *The English at Home* as much as, if not more than, from Walker Evans' *American Photographs* (1938). For *The Americans*, Frank took Brandt's notion of the assemblage of fantastic representations of a nation, arranged by pilgrimage and a private mythology. Frank succumbed to Brandt's generic blackness and severe contrasts, figuring in the miners he photographed in Wales in 1951. But beyond this darkness of "Rotting Hill" Britain, Frank must have been drawn to Brandt as the heroic model, the prototype of what we might call the post-documentary photographer. This was the *existential* part that Brandt had chosen to live out in the second half of the 40's: the photographer who in the age of anxiety and uncertainty confronts nothingness, is burdened with care, but is steadfastly independent, dissenting from the photojournalist consensus of the 40's and 50's.

The Seeing Drive: A Vague Desire, An Unsatisfied Appetite.
In his essay "A Photographer's London" (1948) and in the introduction that Chapman Mortimer derived from him for *Perspective of Nudes* (1961), Brandt tried to assert his new role. He declared his autonomy from that Documentarism with which he had been associated, and attempted to establish a difference between his work of the 30's and his photography of the 40's and 50's. After the phantasy of a British homeland based on childhood memories and pictures that had preoccupied him in the 30's, Brandt announced the project to succeed it: a new orientation, yet one that would continue to conserve his Surrealist-derived strategies and use them to unlock the uncanny in the mundane. He was about to begin an avowedly transcendentalist project. As he wrote in "A Photographers' London": "The photographer must first have seen his subject or some aspect of his subject as something transcending the ordinary."[210] The doxical, informational representation falls away in favor of the forces of Romantic Sym-

bolism that he had partly repressed in the 30's. Brandt's 1948 manifesto, ''A Photographer's London,'' was to be echoed four years later by his collaborator on *Literary Britain*, John Hayward. Deciphering Brandt's photographs, Hayward found that ''their purpose, so it seems to me, is to transcend mere representation of their subject and to arouse, through association and memory, a deeper response.''[211] A numenous world—a world of hidden essences and secreted meanings—is outlined. But, for Brandt, a special prominence is given to visual curiosity, to the universal wish to see, to that drive which Freud identified as scopophilia. For Brandt this drive would uncover ''the essence of things.''[212] ''Very rarely,'' he writes in ''A Photographer's London,'' ''are we able to . . . see for the simple pleasure of seeing. And so long as we fail to do this, so long will the essence of things be hidden from us.''[213] Brandt links to the scopic drive the phantasy of disclosure, the possibility of discovering the inherent strangeness of things, the discovery of *das Unheimliche* through gazing upon photographs.

It was symptomatic that Brandt referred, in ''A Photographer's London,'' not only to his personal mythology of the ''strange'' but also to the vocabulary and conceptual structure of psychoanalysis. ''The ability to see the world,'' he wrote, ''as fresh and strange lies hidden in every human being. In most of us it is dormant. Yet it is there, even if it is no more than a vague desire, an unsatisfied appetite that cannot discover its own nourishment.''[214] Here Brandt intuitively touched upon scopophilia as part of desire, an implacable, ravenous ''appetite'' that is always thwarted, displaced instead upon the phantasm that will support desire. As Lacan was to designate it: ''The question of desire is that the fading subject yearns to find itself again by means of some sort of encounter with this miraculous thing defined by the phantasm.''[215] Brandt insisted that the function of photographs was to feed the scopic drive. ''I believe that it is this that makes the public so eager for pictures. Its conscious wish may be simply to get information. But I think the matter goes far deeper than that. . . .''[216] According to his rendering, the desire to see photojournalistic or informational photography is only the manifest (''conscious'') reason for the scopic drive to uncover the ''strange.'' Paraphrasing the Surrealist program and echoing the close of Man Ray's credo ''The Age of Light,'' Brandt concludes: ''There is given to them again a sense of wonder.''[217]

In the Lumber Room of Family Legend. The early 40's convulsed and oppressed Brandt. The Nazi-Soviet pact and the war with Germany starting in 1939 took their toll; and then, in 1941, chronic illness—diabetes—followed his close escape from the Luftwaffe's firebombing of London. British culture, in the first half of the 40's, adopted a siege condition, imploding upon its revalidated Pastoral, Romantic, and Gothic lineages. Brandt adapted well to this cultural reconfiguration; he could reexploit his private mythology of a British past. Such an occasion occurred when he photographed the South Kensington Science Museum soon after the outbreak of war. He had found only a few exhibits left in the building, but one, a penny-farthing Victorian bicycle, caught his attention and plunged him into a reverie about his family and their British

past. According to family legend,[218] his uncles had ridden such a penny-farthing around indoors, in one of their large mansions in the 1880's. Brandt was attached to those associations, those phantasies that clustered for him around Victorian objects, those fetishes, like the oil lamp he purchased that attended the nudes in the late 40's,[219] and the 6 x 8 Scotland Yard camera he bought in 1944.

The photograph of the penny-farthing was lit from below and juxtaposed with a hand from a puppet—a Surreal ensemble, between Duchamp and Bellmer. On the back of the print, Brandt wrote out his intended ''description'' or caption for a magazine's use. This caption once more disclosed his representation of the uncanny object or scene: ''The country and the museum is closed for the duration [of the war]. . . . A few fantastic objects such as this penny-farthing bicycle have a strange, rather eerie atmosphere, reminiscent of a Hitchcock film.''[220] Brandt was saying that the war had closed off and made reclusive not just cultural institutions but the nation as a whole. People and society and their stereotypes are banished, as they are in *Literary Britain*, and the mind closes

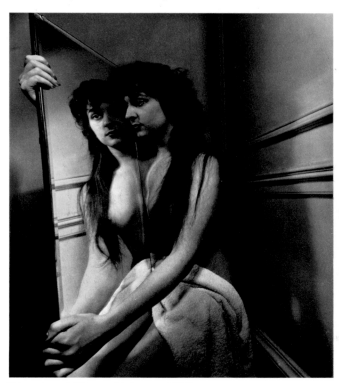

Kismet and Mirror, February 1953

around a ''few fantastic objects.'' All this takes place in a haunted interior as Brandt describes its ''deserted echoing galleries.''[221] The imaginary space of Brandt's nudes was, therefore, being constructed.

Brandt/Hitchcock. It was Alfred Hitchcock whom Brandt cited, assigning the British filmmaker the attributes of uncanniness. He observed his favorite director's development through the 30's up until his move to Hollywood. In the late 30's, Hitchcock's suspense thrillers, like *Sabotage* (1937), underlined Brandt's own preoccupations. *Sabotage* featured two essential Brandtian figures: the withdrawn, observing

European male who watches London with minute interest, and a little boy, Stevie, who also gazes upon the London that passes before him as a *Cherry Stones*-like spectacle of soldiers, rich men, and poor men in the Lord Mayor's parade. Clocks and bowler hats are accorded a sinister aura in a paranoid view of London. By the early 40's Hitchcock had shifted his objectives away from the suspense universe of London types, bobbies, and criminals. In *Rebecca* (1940) he turned to an ultra-romantic text, centered upon an aristocratic country house mysteriously haunted by the memory of a beautiful, beguiling woman. Brandt would certainly have been intrigued by Hitchcock's recentering of suspense and mystery within the territory of a kitsch romantic love story full of melodrama and atmosphere. There exists a very strong isomorphism between Brandt's and Hitchcock's switch to new motifs and thematics in the 40's.

The Stare of the Father. When Brandt described the "strange, rather eerie" penny-farthing, it opened up the valves of private and family memory. We should recall again Freud's definition of the uncanny: "that class of the frightening which leads us back to what is known of old and long familiar." It is the past returning as fetish, like the comic nightmare figure of Colonel Blimp, an aged, reactionary army officer. This fictional character, manufactured by the London *Evening Standard* cartoonist Low, provided the basis for a film that went into production under Powell and Pressburger outside London in 1942. Brandt took still photographs on the set for *Picture Post*. They would accompany a satirical article on Blimp as the incarnation of British-officer caste dogmatism and stupidity, written by the novelist Robert Graves.[222] Brandt's pictures show Blimp as the classic fetish: a petrified and petrifying

"The Awakening of the Child's Mind," 1950:
retouched photograph by André Breton of the painting
by Giorgio de Chirico, "The Child's Brain," 1914

reminder of the "old order" in Britain, "ossified" as the caption claims, directing our reading of the photograph. Blimp, however, has a baleful glare and a patriarchal statuelike body, a phantasm that Brandt represented in the mold of de Chirico's hallucinatory painting of a formidable father figure, *The Child's Brain* (1914). Brandt (and later André Breton) would restore the aggressive glare to de Chirico's figure.[223] This stare is also recovered in the sphinx-like look of the "Micheldever Nude" (1948)—the nude in the house of the father.

The Phantasm at Home. Finally, we should recognize in Brandt's aesthetic a certain principle: a privileging, for the spectator's gaze, of an object, a phantasm, distanced or framed or petrified; an estranged object that is accorded magical or spellbinding powers. We might then see alongside Blimp, the Scilly Isles figureheads, the flea-market mannequin, the fountain in Barcelona, his Victorian statues from the Crystal Palace, Pratt the parlormaid, and the Daughter of the Policeman.[224] We would see more than figures or statuesque, frozen stand-ins for figures; for London itself is, as Brandt wrote, a similar fantastic, "hidden"[225] object. Brandt's account of London, in "A Photographer's London," is a depopulated version of *A Night in London*, as depopulated as the rest of Britain is in Brandt's *Literary Britain*. It is an elided, absent London that he writes of, which when uncovered shows the remains of a mysterious urban folkloric culture, like the graven sphinxes he found and photographed on an Islington doorstep.[226] Here Brandt modeled himself on Atget and on the Surrealists' reading of Atget. He had purchased the first published collection of Atget's photographs in Paris in 1930.

Like the *flâneur* in Louis Aragon's book *Paysan de Paris* (Paris Peasant) (1927), Brandt sketches in "A Photographer's London" the discovery and mapping of a phantasmic London, where he aims to experience "something of the spell it can work as one strolls through deserted streets on a quiet summer's evening, something of the brooding phantasy hidden in its stones."[227] Brandt was nothing if not explicit about this organization of his photography around phantasy. London, as he constructs it in "A Photographer's London," becomes his enigmatic object of desire, and also a sign of the past, with its Islington sphinxes joining part of the Brandtian collection of Victorian antiques. A short biography of Brandt in 1949 claimed: "His two passions are: Victorian furniture—he'll travel long distances to see a really unspoilt Victorian room—and hiking in London."[228] In such Victorian rooms, atmosphere—that 19th-century *Stimmung* that Loos had advocated—and a Symbolist mood or aura is given crowning place in his system. In his own definition in "A Photographer's London," "atmosphere" is: "A combination of elements which reveals the subject as familiar and yet strange."[229] Brandtian "atmosphere" is thus also a countersign for the uncanny, the distant, and the melancholy. His pictured object must be, he claimed, in some way attached like a memory to the viewer. "I doubt whether atmosphere, in the meaning it has for me, can be conveyed in a picture of something which is quite unfamiliar to the beholder."[230] Thus Brandt assembled his phantasmic program for the familiar made strange.

DAVID MELLOR

96

1. Preface to *Photographs by Man Ray 1920–1934*, (Conn., 1934). 2. "Bookmakers' Signals," Pl. 31 in *The English at Home* (hereafter *TEH*) (London, 1936). 3. "Girl Friday" in *Lilliput* (hereafter *L*) (July 1941), p. 39. 4. *Times Literary Supplement*, 10 Sept. 1938, p. 387. 5. Bill Brandt in conversation with the author, Aug. 1974. 6. Bill Brandt, "A Photographer's London" (hereafter *APL*) in *Camera in London* (London, 1948), p. 14. 7. "The Prison" in *Picture Post* (hereafter *PP*), 17 Dec. 1938), p. 69. 8. *Literary Britain* (hereafter *LB*), 1951, Pl. 69. 9. *LB*, Pl. 65. 10. Michel Butor, *Passing Time* (New York, 1969), p. 20. 11. *APL*, p. 14. 12. Michel Butor, "Ombres d'un Ile" in *Ombres d'un Ile* (Paris, 1966), p. 8. 13. *PP*, 18 Jan. 1947, pp. 30–33. 14. Franz Kafka, *The Castle* (1957), p. 9. 15. *PP*, 18 Jan. 1947, pp. 30–33. 16. Cf. "Hampstead Under Snow" in *L* (Feb. 1946), pp. 155–62 and "Frosty Morning in the Park" in *PP*, 20 Jan. 1945, pp. 13–15. 17. Cf. "Hatter's Castle" in *PP*, 20 Sept. 1941; "When Britain Fought Europe" in *PP*, 8 Nov. 1941; and "A Cartoonist's Joke Becomes a Film" in *PP*, 19 Dec. 1942. 18. Rolf Brandt in conversation with the author, 22 Aug. 1984. 19. *L* (May 1945), p. 408ff. 20. Tom Hopkinson, "Bill Brandt, Photographer" in *L* (Aug. 1942), pp. 130, 141. 21. Eva Rakos in conversation with the author, July 1984. 22. *Shadow of Light*, second edition 1977 (hereafter *SL* II), p. 29. 23. *PP*, 31 March 1945, p. 45. 24. Cf. "Top Floor," *A Night in London* (hereafter *ANL*) (London, 1938), Pl. 48. 25. Cf. David Mellor, "The Regime of Flash" in *Floods of Light: Flash Photography 1851–1951* (1982), pp. 28–32. 26. Tom Hopkinson, review: "The Perspective of Nudes" in *The Observer*, 21 May 1961, p. 17. 27. Bill Brandt in conversation with the author, August 1974. 28. Cf. J. Lacan, "The Line and Light" in *The Four Fundamental Concepts of Psychoanalysis* (1979), p. 76. 29. Stephen Bone, Introduction to *ANL*, unpaginated. 30. *ANL*, p. 35. 31. Cyril Connolly, *The Unquiet Grave* (1945; reprint 1961), p. 83, and pp. 66–67. 32. *Shadow of Light*, 2nd edition (1977), Pl. 79. 33. Adolf Loos, *Das Prinzig der Bekleidung* (Vienna, 1898), p. 50. 34. Bill Brandt, "Notes on Perspective of Nudes" in *Swiss Camera*, (hereafter *PN*) in May 1961, p. 7. 35. B. Garavagnuolo, *Adolf Loos* (Milan, 1982), p. 194, 198. 36. P. Eisenman, "From Adolf Loos to Bertholt Brecht" in *Progressive Architecture* no. 5 (1974), p. 92. 37. Bill Brandt, *Camera in London* (hereafter *CL*) (1948), Pl. 36. 38. J. Piper, "The Nautical Style" in *The Architectural Review*, January 1938; reprinted in J. Piper, *Buildings and Prospects* (1948), p. 28. 39. J. Piper, Foreword to *Buildings and Prospects* (1948), p. 8. 40. "Ciel Postiche" in *Minotaure*, vol. II, no. 6 (1935), p. 5. 41. "Au Cimitière des Anciennes Galères" in *Minotaure*, vol. II, no. 6 (1935), p. 4. 42. Inscribed *Wien-London 1934*, indicating it was a fairly immediate response to Brassaï's nude. (Collection Rolf Brandt). 43. Brandt's nude photography occasionally related to Henry Moore's sculpture of the 30's and 40's. The lineage is actually a common indebtedness to Brassaï's photographs of nudes of the early 30's: cf. Christa Lichtenstern, "Henry Moore and Surrealism" in *Burlington Magazine*, vol. XXXIII, no. 944 (Nov. 1981), p. 658. 44. "Over the Sea to Skye" in *L* (November 1947), pp. 389–96. 45. *ANL*, Pl. 44. 46. *TEH*, Pl. 31. 47. *TEH*, Pl. 30. 48. "Speaker in the Park" in *L* (Sept. 1941), p. 198. 49. G. Flaubert, *Madame Bovary* (1857), 1950 ed., p. 16. 50. "Whitechapel" in *Saturday Book* (1943), p. 23. 51. Cf. David Mellor, Introduction to *Bill Brandt: A Retrospective Exhibition* (Bath, 1981), p. 12, for an outline of the course of his commission. 52. *L* (Aug. 1943), p. 116. 53. *TEH*, Pl. 31. 54. *TEH*, Pl. 28. 55. Reproduced in *Das Plakat* (July 1920), between pp. 378–79. 56. Cf. Harold Hutchinson, *The Poster* (1968), p. 61. 57. *TEH*, Pls. 7 and 8. 58. *TEH*, Pl. 8. 59. "The City" in *The Exile*, Autumn 1928. 60. Bill Brandt, "Pictures at Night" in *The Rollei Way*, L.A. Mannheim, ed. (1951), p. 194. 61. Dr. F. Rudolf Uebe, "Die Silhouette in der Reklame Kunst" in *Das Plakat* (Nov. 1919), pp. 373–79. 62. *ANL*, Pls. 28, 45, 60, 41, Pls. 26, etc. 63. *L* (Dec. 1939), pp. 551–58. 64. He recycled "Late Nights in Mayfair," Pl. 52; "Westminster Lies in Darkness," Pl. 54; and "Shad Thames," Pl. 60, from *ANL*. 65. Originally published as "Loneliness" in *L* (Feb. 1938), p. 170. 66. Illustrated in H. Rademacher, *Masters of German Poster Art* (Leipzig, 1966), Pls. 43 and 84. 67. Eva Rakos in conversation with author, July 1984. 68. Dali's enthusiastic endorsement of Art Nouveau/Jugendstil. "Modern Style" as a quarry for his own painting and an exemplary forerunner to Surrealism can be found in *La Femme Visible* (Paris, 1930). 69. A German correspondent of the (London) *Studio* wrote of the opening of the Deutscher Künstlerbund Graphic exhibition held in Hamburg in 1910: "The graphic medium seems best adapted to favour the free, untrammelled development of present day individualism in the arts." Prof. W. Schölermann, "Deutscher Künstlerbund Exhibition of Graphic Art at Hamburg" in *Studio*, vol. 50 (1910), p. 276. 70. The work of Albert Renger-Patzsch, then recently published in *Die Welt Ist Schön* (Munich, 1928), particularly interested him in Vienna and Paris. 71. *APL*, p. 13. 72. Lehmann's *Kriegsanleihe* poster, illustrated in *Das Plakat* (Jan. 1918) between pp. 36 and 37. 73. Schwarzer (cf. Brandt's cult design group, The Six) illustrated in "Selbsbeketnisse" in *Das Plakat* (Jan. 1918), pp. 3–11. 74. Cf. Jean Clair, "Metafisica et Unheimlichkeit" in *Réalismes*, Paris, 1980, p. 30. 75. Cf. Hermine C. Schutzinger, "Angelsächsischer und Deutscher Chauvinism in der Politischen Bildreklame" in *Das Plakat* (March 1919), pp. 142–56. 76. Dr. W. Kurth, "Frank Brangwyns Kriegsplakat erscheinen 1915 bis 1917" in *Das Plakat* (Jan. 1919), pp. 66–67. 77. *TEH*, Pls. 22, 31, 15. 78. Bill Brandt in conversation with the author, Aug. 1974. 79. F. Field, *The Last Days of Mankind* (1967), p. 144. 80. Ezra Pound, "Paris Letter" in *The Dial* (Dec. 1921), pp. 73–78. 81. Eva Rakos in conversation with the author, July 1984. 82. Ernest Hemingway, *Fiesta* (1927; reprint 1964), p. 15. 83. Salvador Dali, "L'amour" in *La Femme Visible* (Paris, 1930); extract in *Salvador Dali/Rétrospective 1920–1980* (Paris, 1980), p. 172. 84. Eva Rakos in conversation with the author, Aug. 1974. 85. Rolf Brandt in conversation with the author, Aug. 1984. 86. "Circus Boyhood" in *TEH*, Pl. 39. The sequence runs from Pl. 39 to Pl. 45. 87. Bill Brandt in conversation with the author, Feb. 1981. 88. Ibid., Aug. 1974. 89. *APL*, p. 14. 90. *SL* II, p. 45. 91. *SL* II, Pl. 44b. 92. *L* (Sept. 1939), pp. 298–99. 93. Cf. the frontispiece to *Living London*, "After the Revels," for these iconographic types, and also the chapter "Midnight London," p. 125–31. 94. *TEH*, Pls. 13, 20, 49. 95. Tallents is quoted in P. M. Taylor, *The Projection of England, 1919–1933* (1981), pp. 119–20. 96. She arranged for Brandt to be escorted around slum areas by a community welfare priest, recollected Eva Rakos in conversation with the author, Aug. 1984. 97. *Times Literary Supplement*, 14 March 1936, p. 225. 98. Cf. *TEH*, Pls. 57 and 58, as a thematically linked pair (the motif of childhood games) of socially and environmentally discontinuous photographs. 99. *Genre* (1982), p. 116. 100. Bill Brandt in conversation with the author, Aug. 1974. 101. *TEH*, Pls. 16, 35, and 40. 102. His father appears as the diner (with Brandt's wife Eva) in *ANL*, Pl. 42; his wife as the sleeper in *ANL*, Pl. 47; his brother as the top-hatted reveler in *TEH*, Pls. 7 and 8, and as the clerk in *TEH*, Pl. 59; and his sister-in-law as the beach girl "Brighton Belle" in *TEH*, Pl. 62. 103. *TEH*, Pls. 25, 49, 30. 104. Rolf Brandt in conversation with the author, Aug. 1984. 105. Ibid. 106. S. Freud, "The Uncanny" in *Collected Works*, vol. XVII, p. 220. 107. *Madame Bovary*, op. cit., p. 51. On the topic of Brandt's Flaubertian allegiance to the archive see Michel Foucault's essay "Fantasia of the Library" in *Language, Counter Memory, Practice* (1977), p. 92. 108. Rolf Brandt in conversation with the author, Aug. 1984. 109. Ibid. 110. W. Stekel, *Patterns of Psychosexual Infantilism* (1953), p. 25. 111. Rolf Brandt in conversation with the author, Aug. 1984. 112. *TEH*, Pl. 35; *ANL*, Pl. 13. 113. Alice M. Raiker's verse *Cherry Stones*, n.d., unpaginated.

114. Bill Brandt to the author, Feb. 1981; Eva Rakos, July 1984; Rolf Brandt, Aug. 1984: all reported what had become a "family legend." 115. Chapman Mortimer, Introduction to *PN*, p. 10. 116. "Pictures by Night," op. cit., p. 191. 117. Cf. Pl. 53, "Dark Alley Way"; three "shady" characters (posed by Rolf Brandt and his friends) are watched at a distance by a policeman under a street lamp. 118. Cf. *ANL*, Pls. 43, 53, 40, 41. 119. Bill Brandt, *Nudes 1945–1980* (hereafter *N*) (1980), Pl. 1, "Hampstead, London," 1945. 120 Cf. Jean-François Lyotard, "Several Silences" in *Driftworks* (New York, 1984), p. 97. 121. Lyotard, "Critical Function," loc. cit., p. 73. 122. *N*, Pl. 7. 123. Jacques Lacan, op. cit., pp. 88–89. 124. *PP*, 1 May 1948, pp. 19–21. 125. Directed by Basil Dearden, and mostly composed of East End London night scenes. 126. *PP*, 31 Jan. 1948, pp. 11–16. 127. Bert Hardy in conversation with the author and Ian Jeffrey, June 1974. 128. *PP*, 31 Jan. 1948, pp. 11–16. 129. *PP*, 8 Jan. 1939, pp. 34–7. 130. *PP*, 4 March 1939, pp. 29–34. 131. *PP*, 8 April 1939, pp. 19–23. 132. *PP*, 29 July 1939, pp. 43–47. 133. *PP*, 8 April 1939, pp. 19–23. 134. *ANL*, Pl. 24. 135. *L* (December 1942), p. 474. 136. Jean-François Lyotard, *Figure-Discours* (Paris, 1971), p. 276. 137. Cf. Imperial War Museum negative D1576 taken by Brandt in Nov. 1940, or *SL* II, Pls. 52–53. 138. Bill Brandt, *L* (Dec. 1942), p. 474. 139. W. Stekel, op. cit., p. 78. 140. Adolph Loos, op. cit., p. 50. 141. W. Stekel, op. cit., p. 78. 142. *L* (Aug. 1943), p. 116. 143. *TEH*, Pl. 32. 144. *TEH*, Pl. 54; *ANL*, Pl. 54. 145. *TEH*, Pl. 50. 146. *ANL*, Pl. 19. 147. *ANL*, Pl. 57. 148. *TEH*, Pl. 30. 149. Bill Brandt in conversation with the author, Aug. 1974. 150. Paul Eluard, "Physique de la Poésie" in *Minotaure*, no. 6 (Winter 1935), p. 6. 151. *TEH*, Pl. 29. 152. Lewis Carroll, *Alice in Wonderland*, Chapter VIII. 153. Ibid. 154. *TEH*, Pls. 47 and 48; *ANL*, Pls. 56 and 57. 155. *TEH*, Pl. 50. 156. *L* (May 1939), p. 500. 157. *ANL*, Pl. 44. 158. The male model for this tableau was another friend of Brandt's in London, George Szulyovszky. 159. Butor, op. cit., p. 8. 160. "Les Plus Belles Cartes-Postales" in *Minotaure*, no. 1 (1933). 161. *Minotaure*, vol. II, no. 5 (1934), p. 18. 162. Cf. *The Philosopher and the Poet* (1914), the statue in *Double Dream of Spring* (1915), and the figure in *The Joy of Return* (1915). 163. The image of the sequestered woman had been a commonplace of the late Romantic and the Symbolist imagination; cf. Tennyson's *The Lady of Shalott* and Pre-Raphaelite painter Holman Hunt's portrait of that subject. 164. *ANL*, Pl. 24. 165. Ibid. 166. G. Flaubert, op. cit., p. 50. 167. *L* (Nov. 1940), p. 423. 168. B. de Saint-Pierre, "Paul et Virginie" in *Etudes de la Nature*, vol. IV (Paris, 1787). 169. *L* (Sept. 1941), pp. 235–42. 170. "Surrealism: The Last Snapshot of the European Intelligentsia" in *One Way Street* (1979), p. 231. 171. *PP*, 12 July 1941. 172. Job No. 832 for *PP*; this photo-story was killed by the editor. 173. *PP*, 26 Sept. 1942. 174. *ANL*, Pl. 27, "Bloomsbury Party." 175. Bill Brandt in conversation with the author, March 1983. 176. Cf. "Our Neglected Gardens" in *Harper's Bazaar*, June 1944, p. 42. 177. Bill Brandt in conversation with the author, March 1983. 178. "Minutes of the Home Planning Committee," 20 Nov. 1940, item 343. 179. "Au Cimitière des Anciennes Galères," loc. cit. 180. Cf. Ernest Hemingway, *88 Poems*, ed. Nicholas Georgianis (New York, 1979), p. 42 and 70–73. 181. Quoted in Laurence R. Broer, *Hemingway's Spanish Tragedy* (Alabama, 1973), p. 5. 182. *SL* II, 59. 183. In the author's Introduction to the RPS catalogue *Bill Brandt: A Retrospective* (1981), p. 8. Originally published in *L* (Nov. 1937), p. 54. 184. Jean Genet, *The Thief's Journal* (1967), p. 12–13 (author's emphasis). 185. *SL* II, Pl. 37. 186. Only one of these photographs, of a drunk gypsy, has ever been reproduced; in *L* (March 1938), p. 260. 187. *L* (March 1947), pp. 265–76. 188. *L* (Aug. 1947), pp. 155–260. 189. *L* (Sept. 1947), pp. 389–96. 190. Subsequently killed: *PP* Job No. 1048. Cyril Connolly's jeremiad about London occurs in his Introduction to *The Unquiet Grave*, op. cit., p. XI. 191. *L* (March 1947), pp. 265–76. 192. Wyndham Lewis, *Rotting Hill* (1951), p. VIII. Brandt lived on Campden Hill, on the border of Notting Hill, the district Lewis writes of and that was probably Brandt's favorite London area. 193. *L* Sept. 1946 194. *N*, Pl. 2. He wrote to Eva in 1947: "I have just discovered 'the little nude.'" 195. *L* (Aug. 1947), p. 155. 196. *L* (March 1947), p. 265. 197. Ibid., p. 171. 198. Kurt Hielscher, *Deutschland* (Leipzig, 1931). 199. Except, that is, for a solitary plowman in *LB*, Pl. 52, "Near Clunbury," who corresponds to the Ploughboy in Raiker/Crombie's *Cherry Stones*. 200. Bill Brandt in conversation with the author, Aug. 1974. 201. J. Baudrillard, op. cit., pp. 65–66. 202. Ezra Pound, op. cit., pp. 73–78. 203. G. Watson, "Did Stalin Dupe the Intellectuals?" in *Politics and Literature in Modern Britain* (1977), pp. 46–70. 204. At Marx House in the summer of 1940 in a joint exhibition of photographs with the Viennese-born communist Edith Tudor Hart. Cf. "Modern Photography at Marx House" in *New Statesman*, 27 July 1940, p. 88. 205. Eva Rakos in conversation with the author, Aug. 1984. 206. Chapman Mortimer, op. cit., p. 9. 207. Cf. the comment of a reviewer on *ANL*: "Nor has he succeeded in concealing his artifice." *Times Literary Supplement*, 10 Sept. 1938, p. 587. 208. Barbara Johnson in *Untying the Text*, R. Young, ed. (1981), pp. 166–67 209. *L* (Sept. 1942), p. 141. (author's emphasis). 210. *APL*, p. 14. 211. *LB*, p. IX. 212. *APL* p. 15: (author's emphasis). 213. Eva Rakos in conversation with the author, July 1984. 214. *APL*, p. 15. 215. J. Lacan in *The Structuralist Controversy*, E. Donato and R. Macksey, eds. (1971), p. 194. 216. *APL*, p. 15. 217. Ibid. 218. Eva Rakos in conversation with the author, July 1984. 219. E.g. *N*, Pls. 5, 6, 12. 220. Collection Noya Brandt, London. 221. Collection Noya Brandt, London. 222. "Cartoonist's Joke Becomes Film Hero," loc. cit., pp. 14–17. 223. In 1950, André Breton added staring eyes to a reproduction of de Chirico's *The Child's Brain*, thus restoring the castrating power of the father that the painter had sought to repress in his picture. Cf. *The Awakening of the Child's Mind*, Almanach Surréaliste du Demi-Siècle (Paris, 1950). 224. We have referred already to the Hitchcockian connotations of this title. Brandt actually derived it from the title of Swinburne's Victorian melodramatic novel *The Daughter of the Policeman*. The book reached his attention through an article devoted to it in *Minotaure*, no. 5 (Winter 1935), pp. 62–65. The same issue carried Carroll's original drawing of Alice cramped and a giantess in the White Rabbit's room; a reproduction from Arthur Rackham's illustrations to *Ondine* (1912); Bellmer's doll nudes *La Poupée*; and Brassaï's *Ciel Postiche*. This was the same issue in which Brandt's Scilly Island fetishes were published: altogether a great repertory of phantasms to stock Brandt's imagination. 225. *APL*, p. 9. 226. *APL*, p. 9. 227. *APL*, p. 10. 228. "Our contributors." in *L* (Feb. 1949), p. 124. 229. *APL*, p. 11. 230. *APL*, p. 12.

BIBLIOGRAPHY

The English at Home. Introduction by Raymond Mortimer. Batsford, London, 1936.

A Night in London. The story of a London night. Country Life, London, Arts et Métiers Graphiques, Paris and Charles Scribner's Sons, New York, 1938.

Camera in London. Introductory essay by Bill Brandt. Commentary by Norah Wilson. Focal Press, London, 1948.

Literary Britain. Introduction by John Hayward. Cassell, London, 1951.

Perspective of Nudes. Preface by Lawrence Durrell. Introduction by Chapman Mortimer. Bodley Head, London, 1961. Also issued as *Perspectives sur le Nu,* Paris, 1961.

Shadow of Light. A collection of photographs from 1931 to 1966. Introduction by Cyril Connolly; notes on the plates by Marjorie Becket. Bodley Head, London and Viking Press, New York, 1966. Also issued as *Ombre d'une Ile,* Paris, 1967. Second Edition, with an additional introduction by Mark Haworth-Booth. The Gordon Fraser Gallery Limited, London and Bedford; Da Capo Press Inc., New York, 1977.

Bill Brandt: Photographs. Introduction by Aaron Scharf. Arts Council of Great Britain, London, exhibition catalogue, 1970.

Bill Brandt: Early Photographs 1930–1942. Introduction by Peter Turner. Arts Council of Great Britain, London, catalogue, 1975.

Bill Brandt: Nudes 1945–1980. Introduction by Michael Hiley. The Gordon Fraser Gallery Limited, London and Bedford; The New York Graphic Society/Little, Brown and Company, 1980.

Photographs by Bill Brandt. Introduction by Mark Haworth-Booth. International Exhibitions Foundation, Washington, D.C., 1980.

Bill Brandt: A Retrospective Exhibition. Introduction by David Mellor. The Royal Photographic Society, National Centre of Photography, Bath, exhibition catalogue, 1981.

Bill Brandt: Portraits. Introduction by Alan Ross. The Gordon Fraser Gallery Limited, London and Bedford; University of Texas Press, Austin, 1982.

Bill Brandt: Portraits. Introduction by Richard Ormond. National Portrait Gallery, London, exhibition catalogue, 1982.

Bill Brandt: War Work. The Photographers Gallery, London, exhibition catalogue, 1983.

Literary Britain. Introduction by John Hayward. Edited and with an afterword by Mark Haworth-Booth. Victoria and Albert Museum, London, 1984.

Bill Brandt: London in the Thirties. Gordon Fraser Gallery Limited, London, 1984. Also published with an introduction by Mark Haworth-Booth, Pantheon Books, New York, 1984.

CREDITS

Pages 15–23, 27–29, 33, 35, 38–40, 43, 46, 48, 53–61, 63, 66–68, 70, 72, 87, 91, 95, 99, back cover courtesy of and reproduced by the kind permission of Mrs. Noya Brandt. Pages 6–11, 14 courtesy of R. A. Brandt. Pages 12, 79, 82, 88 from *The English at Home;* B. T. Batsford Ltd., London, 1936. Front cover and pages 13, 25, 30, 31, 36, 37, 41, 44, 51, 65, 69, 71, 77, 78, 82, 84, 85 courtesy of Marlborough Fine Art Ltd. Pages 2, 34, 45 courtesy of the Victoria and Albert Museum, London. Pages 42, 49 courtesy of the National Portrait Gallery, London. Page 47 courtesy of Michael E. Hoffman. Page 72 from *Picture Post,* January 18, 1947. Page 73 from *Lilliput,* February, 1949. Page 74 from *Picture Post,* March 31, 1945. Pages 75, 83, 90, 92 courtesy of Eva Rakos. Page 76 from *Minotaure* magazine, volume II, no. 6, 1934. Page 77 from Alfred Hitchcock's *The Ring,* 1927. Page 84 from *A Night in London,* Country Life, London, Arts et Métiers Graphiques, Paris and Charles Scribner's Sons, New York, 1938. Page 86 from *Picture Post,* May 1, 1948. Page 86 from *Picture Post,* January 31, 1948. Page 91 from *Picture Post,* July 4, 1942. Page 93 from *Camera in London,* The Focal Press, 1948. Page 94 illustration by John Tenniel from *Through the Looking-glass and What Alice Found There,* MacMillan Publishing Company, 1962. Page 96 from the *Almanach Surréaliste du demi-siècle,* Paris, 1950.

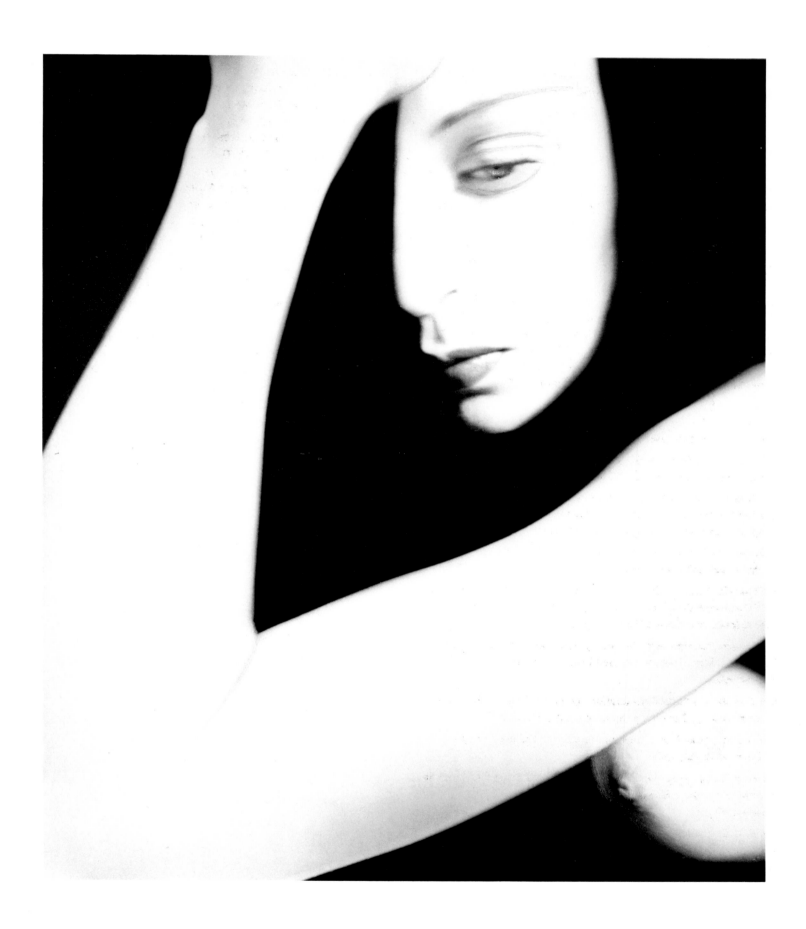

99 London, 1952